The Sweeter Side of R. CRUMB

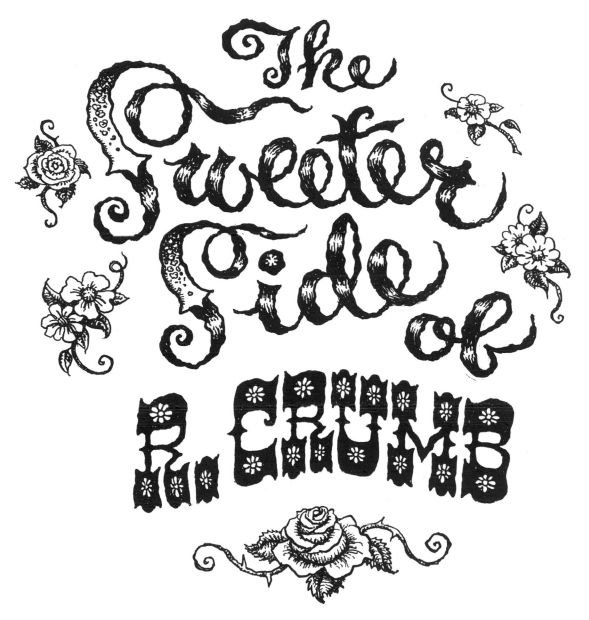

The Sweeter Side of R. CRUMB

BEING A DELIGHTFUL COLLECTION OF ADORABLE, HEART-WARMING AND LOVINGLY RENDERED DRAWINGS WHICH, I PROMISE, WILL NOT MAKE YOU FEEL THREATENED IN ANY WAY, AND WILL PUT YOU IN A STATE ALL WARM AND FUZZY AND CUDDLY TOWARDS THE ARTIST AND LIFE IN GENERAL.

MQP

First published by MQ Publications Limited
12 The Ivories, 6–8 Northampton Street
London N1 2HY
Tel: 020 7359 2244 Fax: 020 7359 1616
email: mail@mqpublications.com
website: www.mqpublications.com

ISBN (10) 1-84601-114-0
ISBN (13) 978-1-84601-114-6

1 3 5 7 9 0 8 6 4 2

INTRODUCTION
by MR. NICEY-NICE HIMSELF

SWEET SIDE?? R. CRUMB?? THAT NASTY, NEGATIVE, MISANTHROPIC SEX PERVERT?? WHO YA TRYIN' TA KID?! HEY, NO, REALLY, THERE IS A "SWEETER SIDE", AND THIS BOOK PROVES IT, GOD DAMMIT! IN THESE PAGES IS THE EVIDENCE, SCRAPED TOGETHER AFTER A DILIGENT SEARCH OF ALL MY PAST ARTWORK. ADMITTEDLY, THERE WASN'T MUCH. WE HAD TO LOOK LONG AND HARD, MY WIFE ALINE AND I. BEING SORTA SWEET HERSELF, I LET HER BE THE FINAL JUDGE. I COULDN'T TELL. SHE NIXED ALOT OF THE DRAWINGS THAT I PULLED OUT FOR INCLUSION. "YOU CALL THAT SWEET?" SHE WOULD SAY, "I DON'T THINK SO!" "IT'S NOT?" I WOULD ASK, ALL BEWILDERED, "WHY, WHAT'S WRONG WITH IT?" "WELL, LOOK AT IT! YOU THINK THAT CREEPY, DISTURBING IMAGE IS SWEET?!" THEN SHE WOULD GIVE A DERISIVE CHUCKLE AND SHAKE HER HEAD...NOT THAT HER ARTWORK IS EXACTLY "SWEET" EITHER, AND CAN BE PRETTY DISTURBING IN ITS OWN WAY!

SO, I DON'T KNOW...I CAN'T TELL IF MY WORK EVER HAS ANY QUALITY ABOUT IT THAT COULD BE CHARACTERIZED AS "SWEET." MAYBE THE CLOSEST I COME IS SOME OF THE AFFECTIONATE DRAWINGS I'VE DONE OF MY TWO WIVES AND MY TWO CHILDREN...AND VARIOUS GIRL-FRIENDS... SOMETIMES... I DUNNO ... IT'S HARD TO DRAW ATTRACTIVE WOMEN...*

SEE, MOSTLY I THINK "SWEETNESS" IS A PLOY, A DEVICE, A TECHNIQUE, A PUTTING ON OF CHARM TO SEDUCE, TO SOFTEN UP THE "MARK." ONE OF THE BEST-KNOWN SECRETS OF SELLING ANY COMMODITY IS TO MAKE IT ATTRACTIVE TO WOMEN, SINCE THEY DO MOST OF THE SHOPPING AND THE CONSUMING. I LEARNED THIS BIT OF BUSINESS CUNNING WHILE WORKING FOR A GREETING CARD COMPANY WHEN I WAS JUST STARTING OUT ON MY FABULOUS CAREER. I WAS TOLD OVER AND OVER THAT MY WORK WAS "TOO GROTESQUE." THEY TAUGHT ME THE FORMULA FOR DRAWING CUTE CHARACTERS. IT DIDN'T COME NATURALLY TO ME. I HAD TO WORK AT IT. I SUPPOSE THAT JOB GAVE ME MY FILL OF CUTENESS.

BUT SWEETNESS AND CUTENESS HAVE A PERENNIAL APPEAL TO WOMEN, UNLESS YOU'RE ONE OF THESE YOUNG CONTRARY PUNKS OR AN ALIENATED ART GIRL, LIKE MY DAUGHTER.... COME TO THINK OF IT, EVEN SHE CAN STILL GO ALL SAPPY AND MUSHY OVER CUTE LITTLE KITTIES AND PUPPIES AND BABIES AND SAD-EYED LOST BOYS. ALL THOSE TOUGH YOUNG GIRLS OF TODAY STILL LIKE THEIR BAD BOYS TO BE CUTE! SO THERE YOU ARE...MY WORK DOESN'T EVEN HAVE BAD BOY APPEAL...IT'S JUST PLAIN WEIRD... YOU KNOW, ICKY... YUCKY... AND I CAN'T EVEN HOLD IT AGAINST THEM OR BLAME THEM...IF I WERE A WOMAN, I PROBABLY WOULDN'T LIKE MY WORK EITHER. SO, I HAVE TO SHRUG OFF THEIR HATRED OF ME AND FORGET ABOUT THEM AS AN AUDIENCE.

IT WAS DECIDED TO USE THE WORD "SWEETER" IN THE TITLE BECAUSE IT INDICATES THAT IT'S ALL RELATIVE. THE WORK IN THIS BOOK COULD BE SAID TO BE SWEETER THAN MOST OF MY STUFF. I SAY, "IT WAS DECIDED" BECAUSE THE TRUTH IS, THIS "SWEET" ANGLE WAS COOKED UP BY ALINE AND THE PUBLISHER, ZARO WEIL. THEY PUT THEIR HEADS TOGETHER TO SEE IF THEY COULD DREAM UP SOME KIND OF PREMISE FOR A CRUMB BOOK THAT MIGHT STAND HALF A CHANCE WITH THE FEMALE MARKET. AS FAR AS I CAN TELL, MOST OF M.Q.P.'S BOOKS SEEM TO BE TARGETED AT WOMEN. NOT THAT THESE POTENTIAL WOMEN BUYERS WOULD GET THIS BOOK FOR THEMSELVES, BUT MAYBE THEY'D BE ABLE TO STOMACH IT ENOUGH TO BUY IT AS A GIFT ITEM FOR THEIR BOYFRIENDS, OR FOR SOME GUY THEY KNOW WHO, FOR REASONS UNFATHOMABLE TO THEM, IS A FAN OF R. CRUMB. AND SO MY DEAR FRIENDS, LADIES INCLUDED, I HOPE, YOU HOLD IN YOUR HAND A BOOK OF NICE DRAWINGS BY R. CRUMB, THE TENDER MOMENTS, EXPRESSIONS OF FOND AFFECTION... I WONDER IF THIS "SWEETER SIDE" ANGLE WILL PUT IT ACROSS... WELL, HELL, ZARO WILL SELL IT...SHE'S A KILLER SALESWOMAN. SHE GOES OUT ON THE ROAD AND PITCHES HER BOOKS FAR AND WIDE. GO ZARO! DO YOUR THING!

—R. CRUMB, SOUTH OF FRANCE
MARCH, 2006

* IN THE INTEREST OF AVOIDING DUPLICATION OF ALREADY PUBLISHED MATERIAL I HAVE PURPOSELY LEFT OUT OF THIS BOOK ALL DRAWINGS WHICH WERE INCLUDED IN THE BOOK GOTTA HAVE 'EM — PORTRAITS OF WOMEN, PUBLISHED BY GREYBULL PRESS IN 2002.

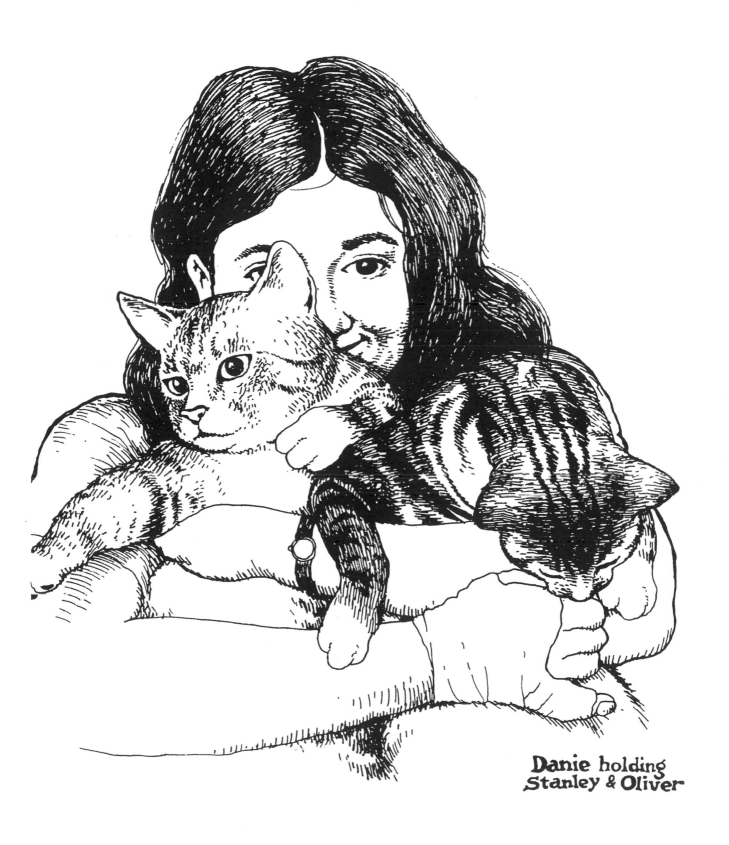

Danie holding
Stanley & Oliver

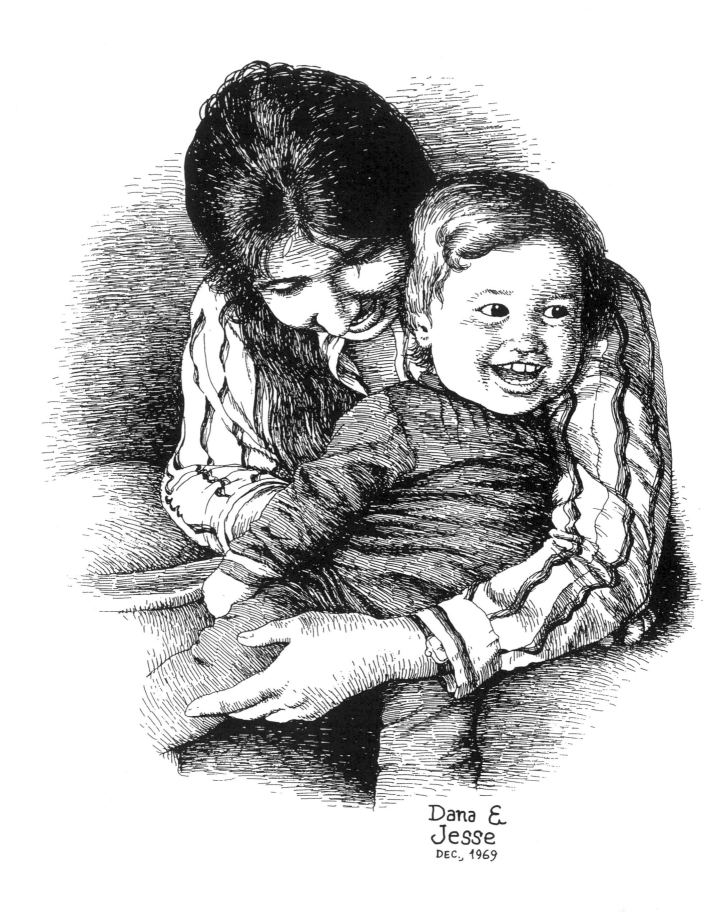

Dana & Jesse
DEC., 1969

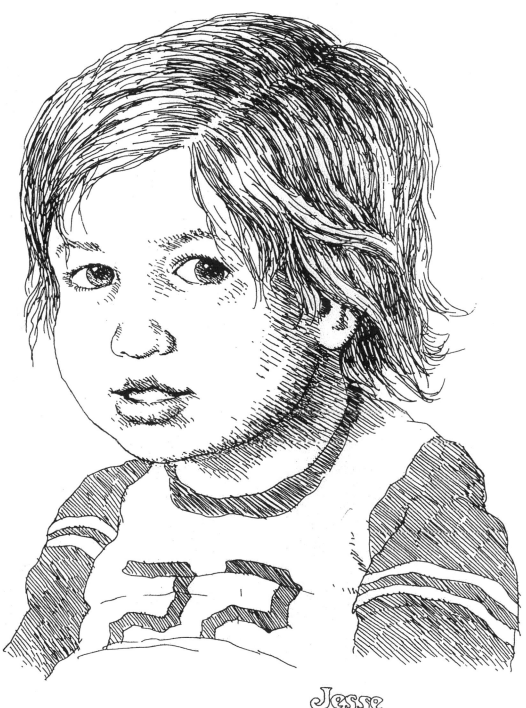

Jesse
(CRAZIES · BOYS)
Crumb
December, 1971

PHOEBE

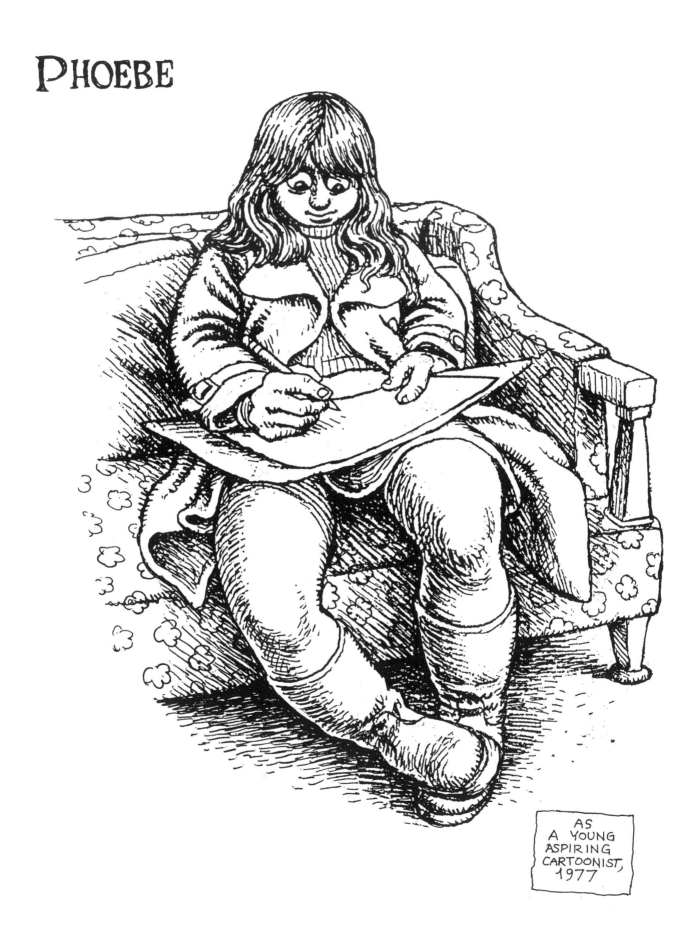

AS A YOUNG ASPIRING CARTOONIST, 1977

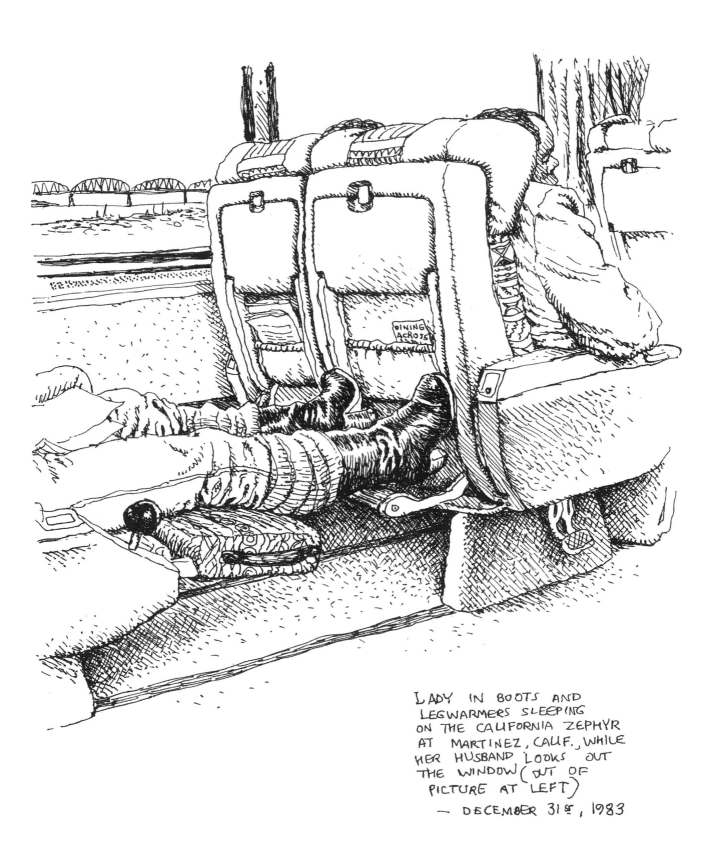

LADY IN BOOTS AND
LEGWARMERS SLEEPING
ON THE CALIFORNIA ZEPHYR
AT MARTINEZ, CALIF., WHILE
HER HUSBAND LOOKS OUT
THE WINDOW (OUT OF
PICTURE AT LEFT)
— DECEMBER 31ST, 1983

SOPHIE

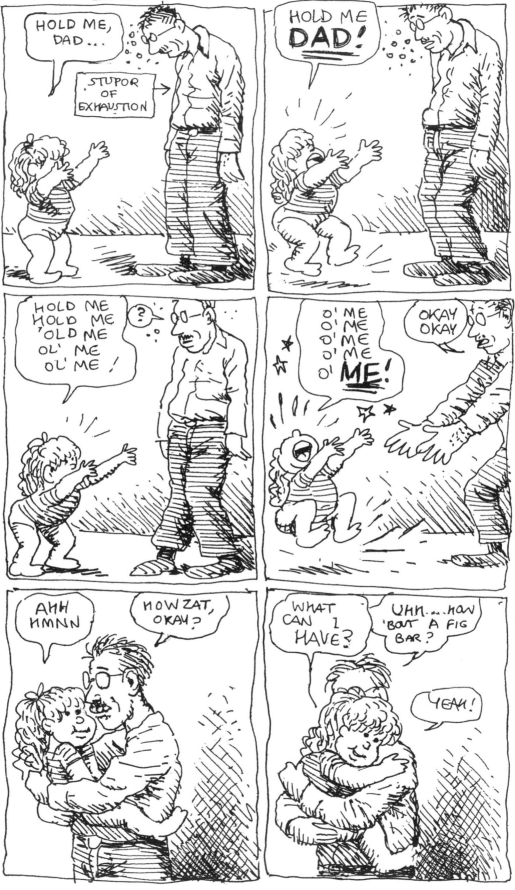

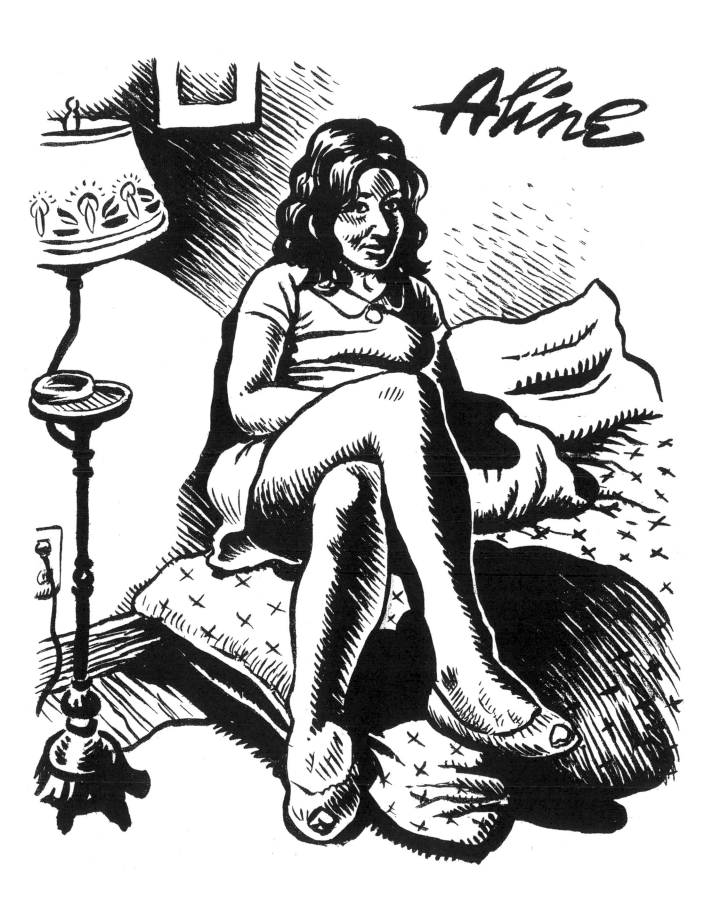

HIPPIE GIRL PLAYING PIANO
AT THE "BLUE MANGO" IN DAVIS.
(SHE ACCOMPANIED SHAGGY BEARDED
HIPPIE MAN, WHO PLAYED VIOLIN. THEY
PLAYED SOLEMN CLASSICAL MUSIC, SOME
OF IT ORIGINAL COMPOSITIONS. THEY
CALLED THEMSELVES "THE WINDOWS.")

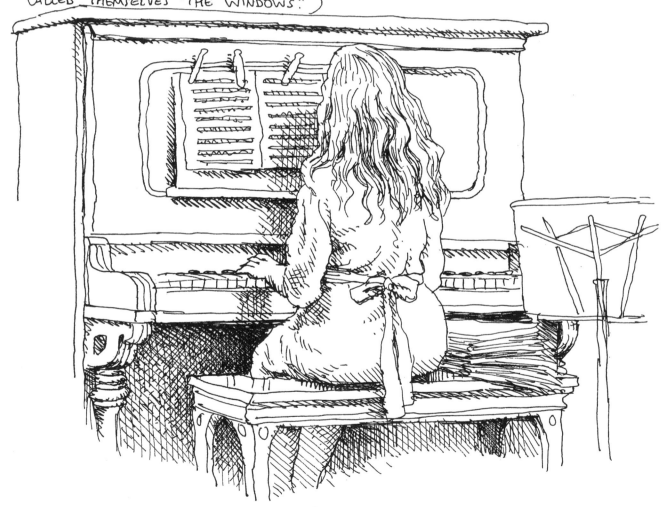

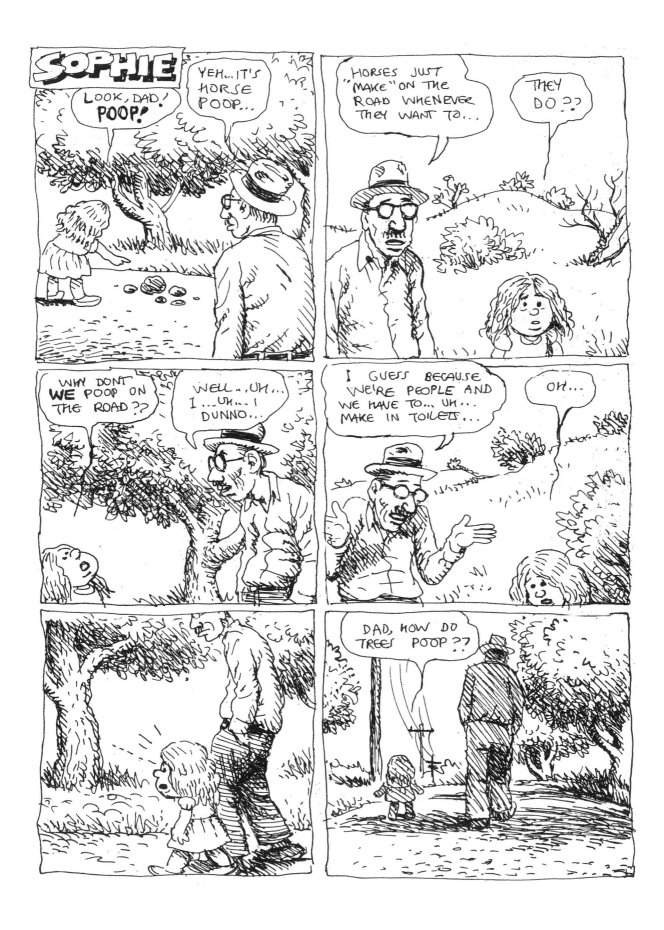

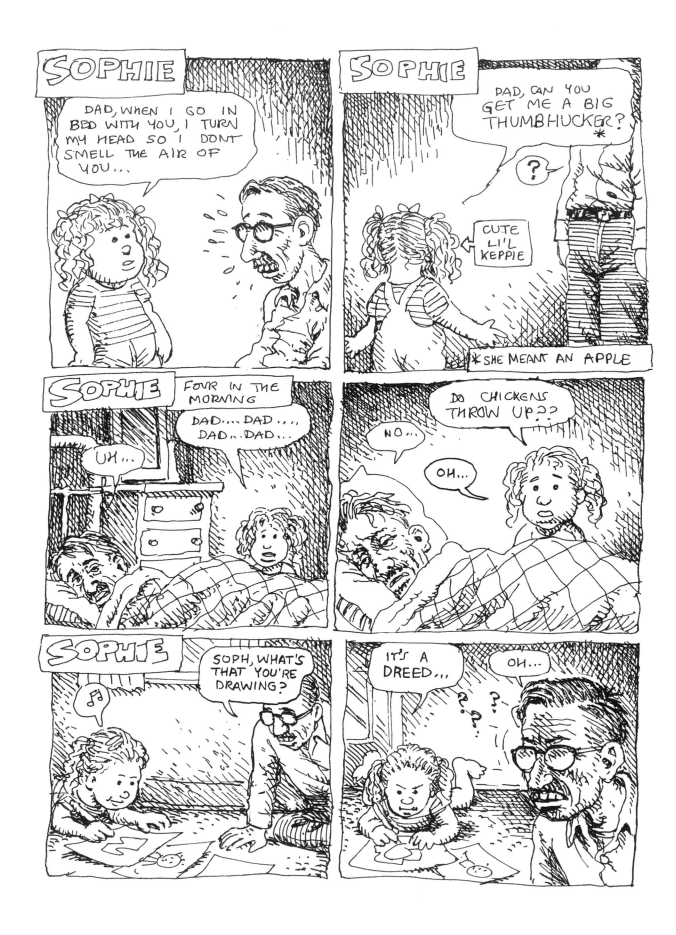

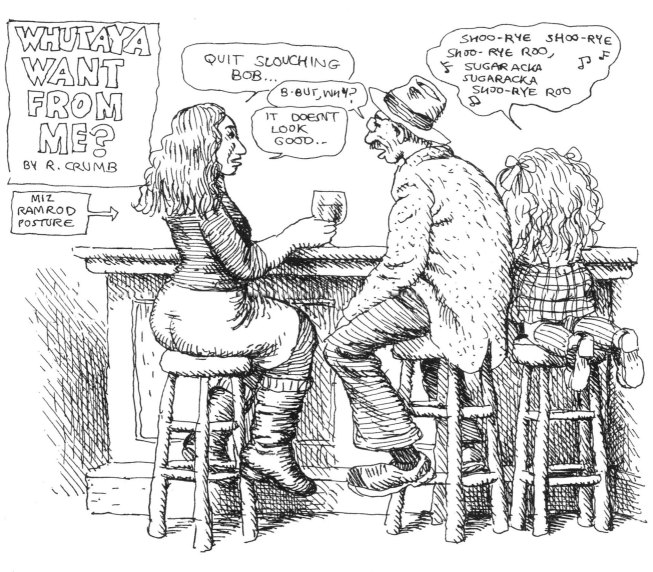

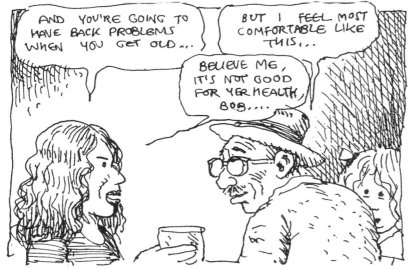

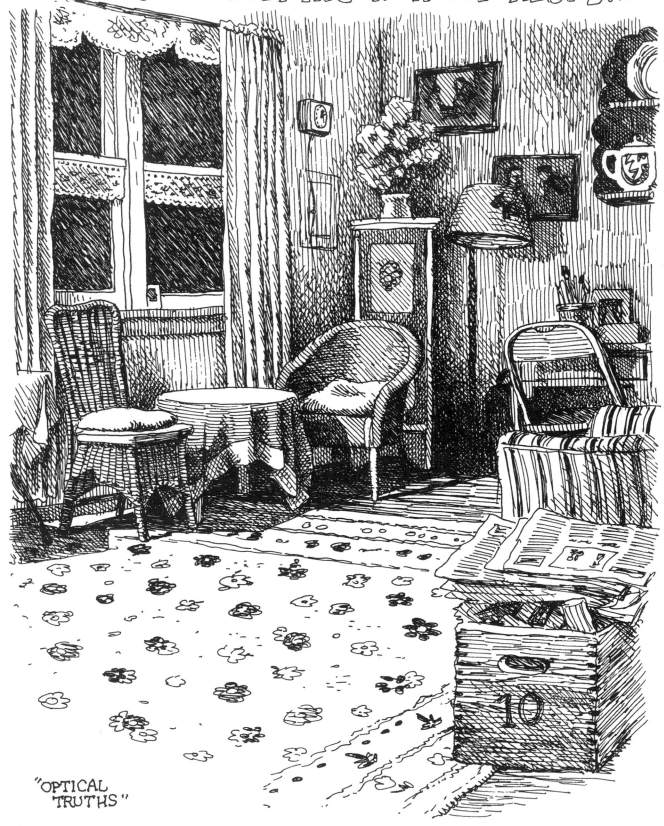

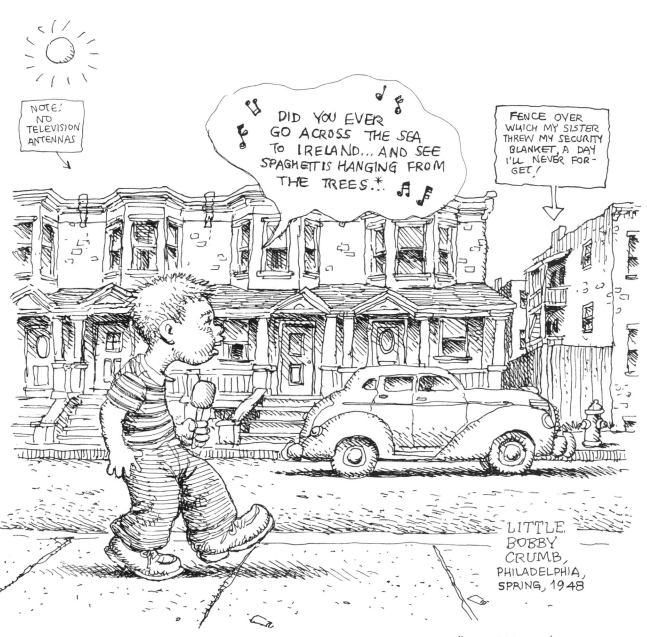

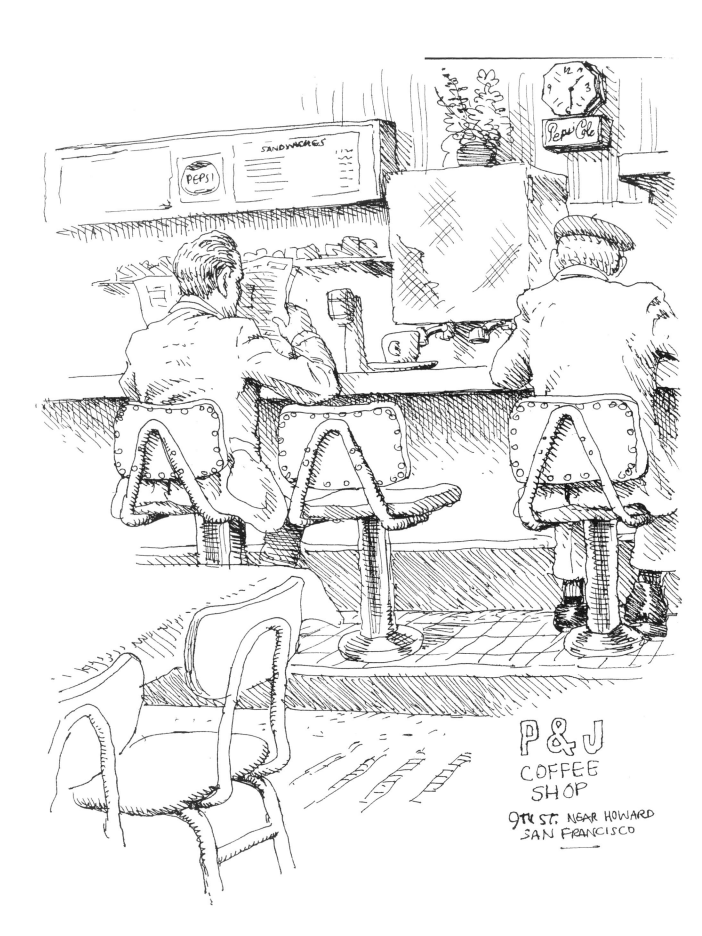

PEPSI

SANDWICHES

PepsiCola

P & J
COFFEE
SHOP
9TH ST. NEAR HOWARD
SAN FRANCISCO

A HALF HOUR
TIL THE BUS COMES....

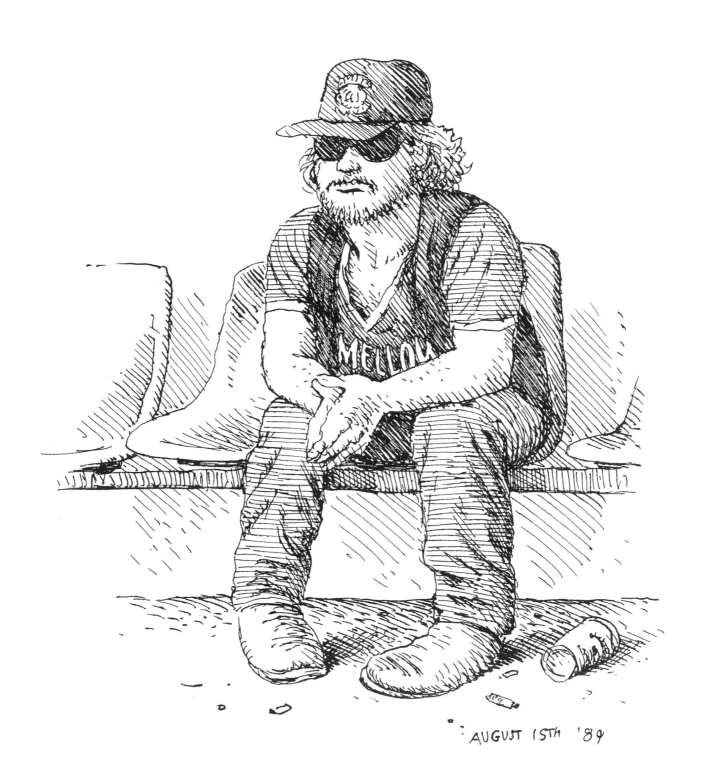

AUGUST 15th '89

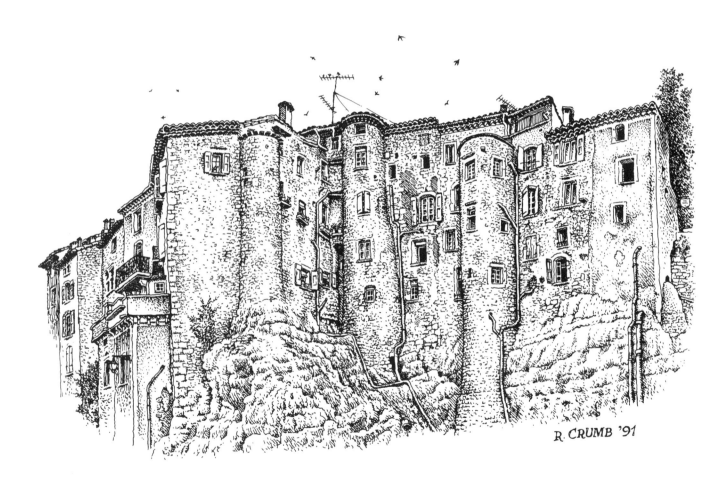

LE FRONT DE SAUVE

R. CRUMB '91

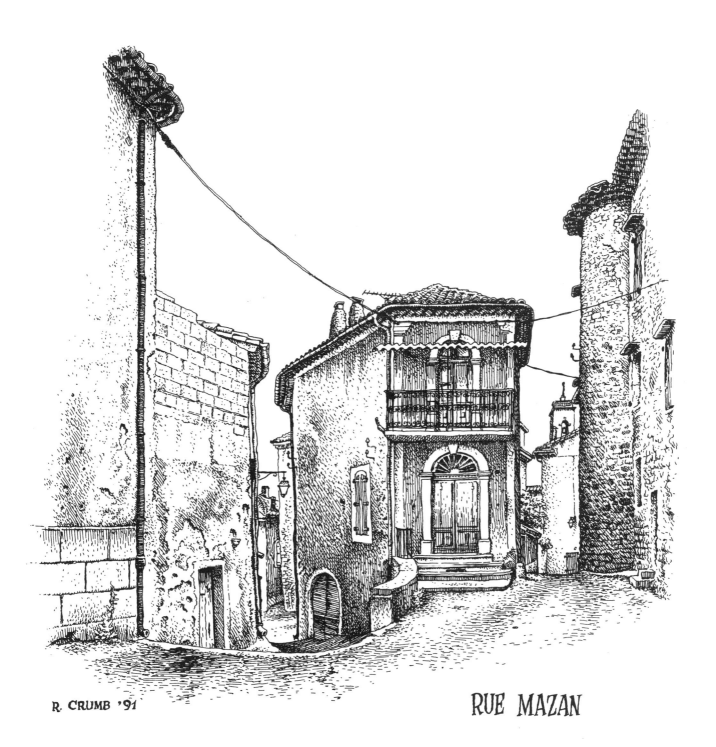

R. CRUMB '91

RUE MAZAN

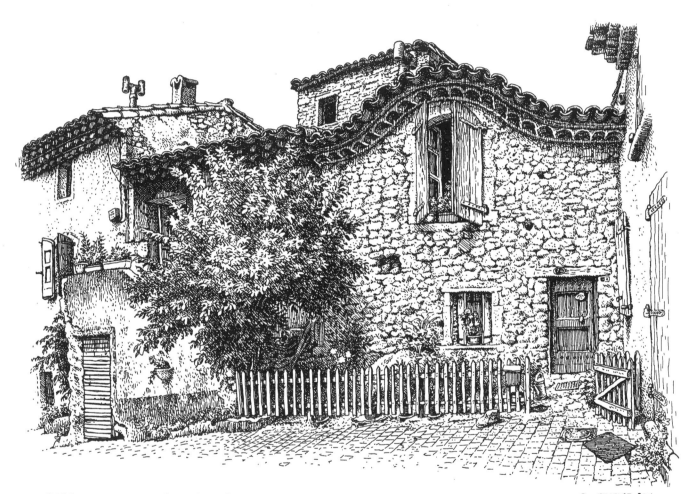

RUE du TERRAIL ~ HAUT

R. CRUMB '91

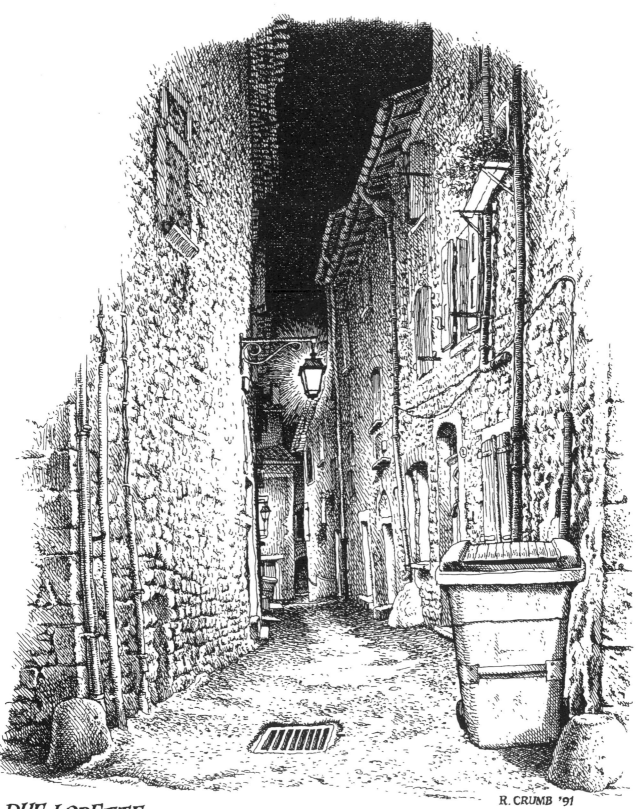

RUE LORETTE

R. CRUMB '91

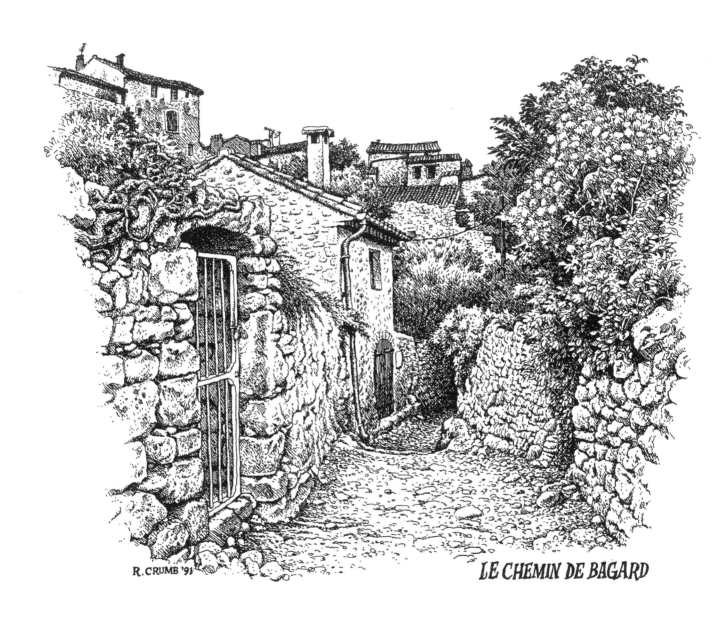

R. CRUMB '91

LE CHEMIN DE BAGARD

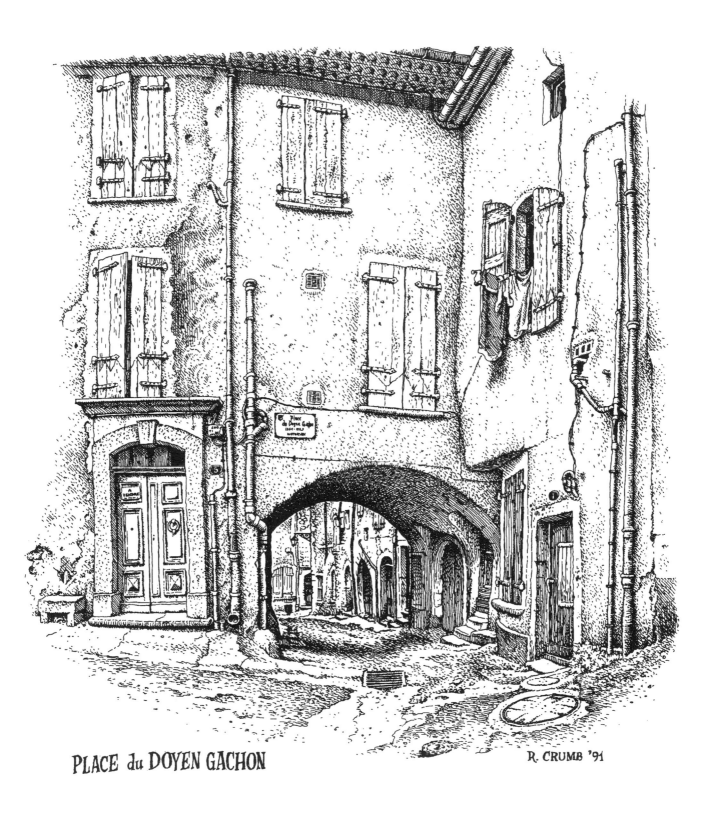

PLACE du DOYEN GACHON R. CRUMB '91

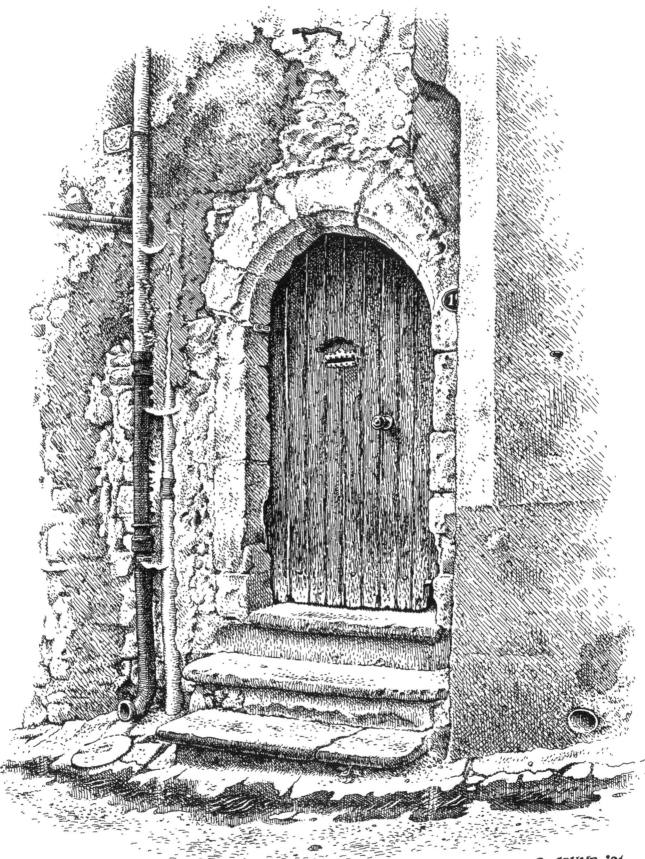

RUE du PONT VIEUX

R. CRUMB '91

GIRL RUNNING ACROSS THE STREET IN PARIS IN THE RAIN...

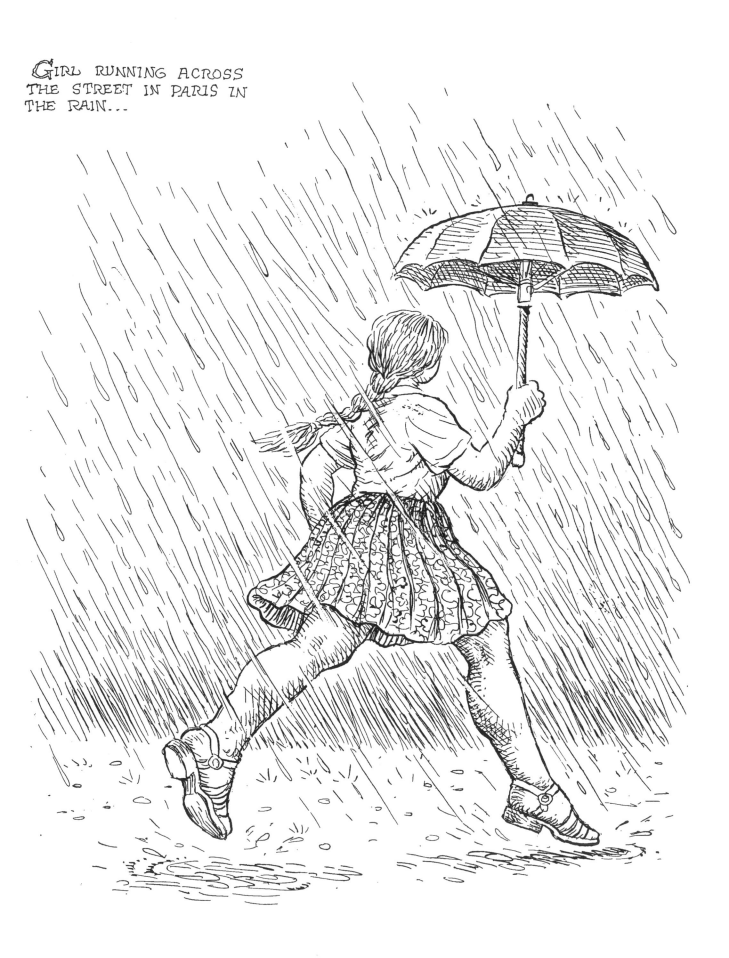

STARS of Columbia Records North-African Series
CIRCA 1930

Lili~Labassi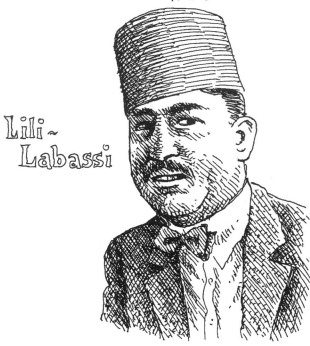

Ksentini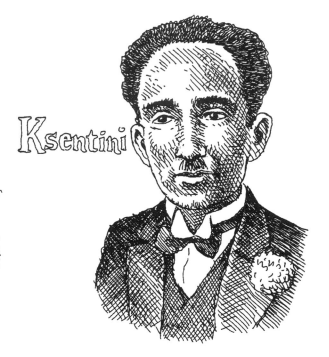

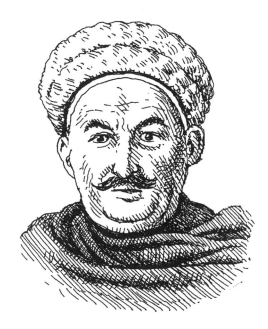 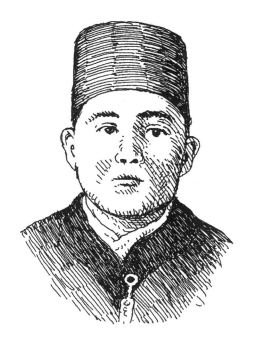

Cheikh Larbi
& his son Redouane

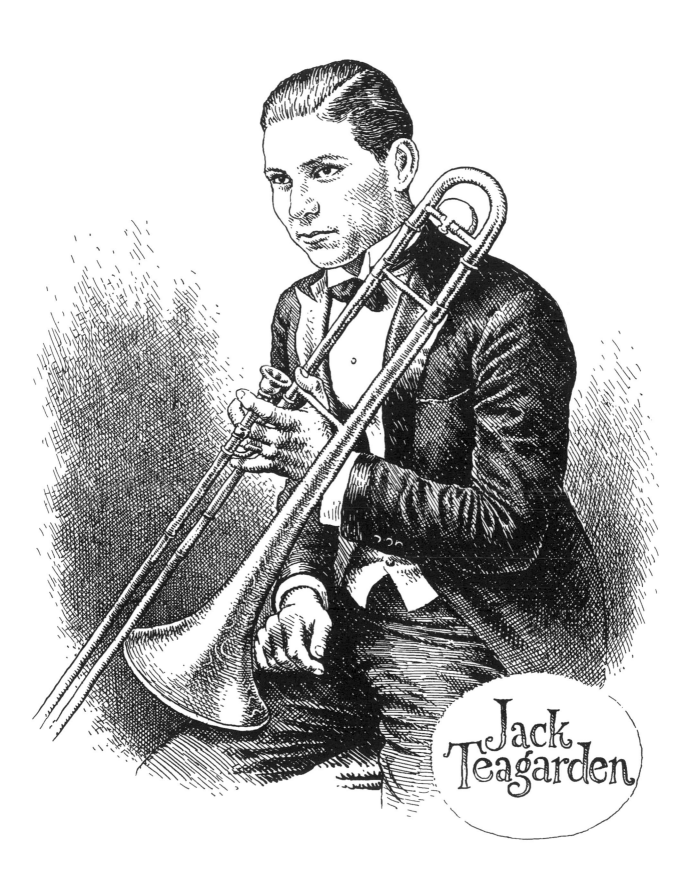

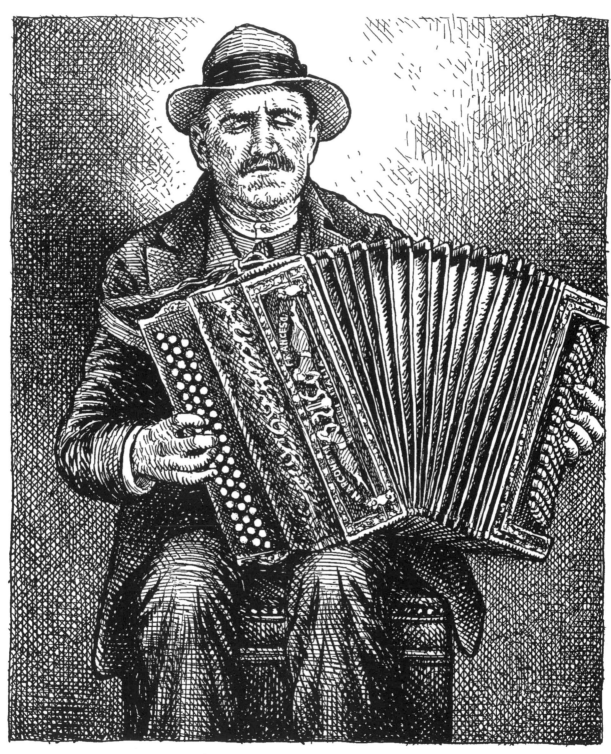

NARCISSE

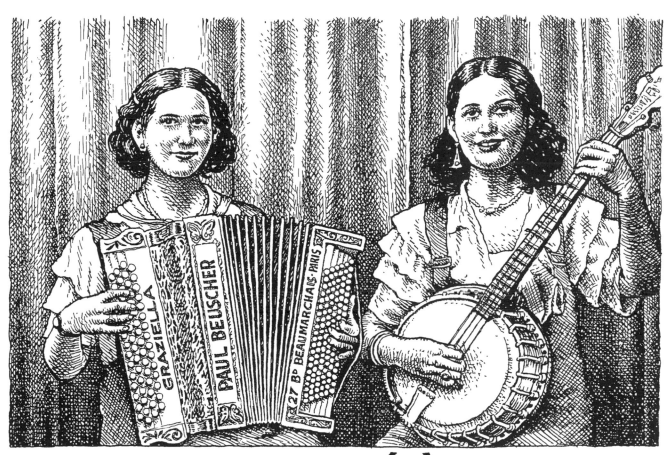

GRAZIELLA et MERCÉDÈS SABATIER

PIERS THE PLOUGHMAN by WILLIAM LANGLAND
BOOK VIII : THOUGHT

"So I wandered far and wide, and walked alone over a wild common and by a woodside, where I stayed listening to the singing of the birds. And as I lay down for awhile in a glade under a lime-tree, listening to their sweet songs, their music lulled me to sleep."

(WRITTEN IN THE LATE 1300S IN ENGLAND)

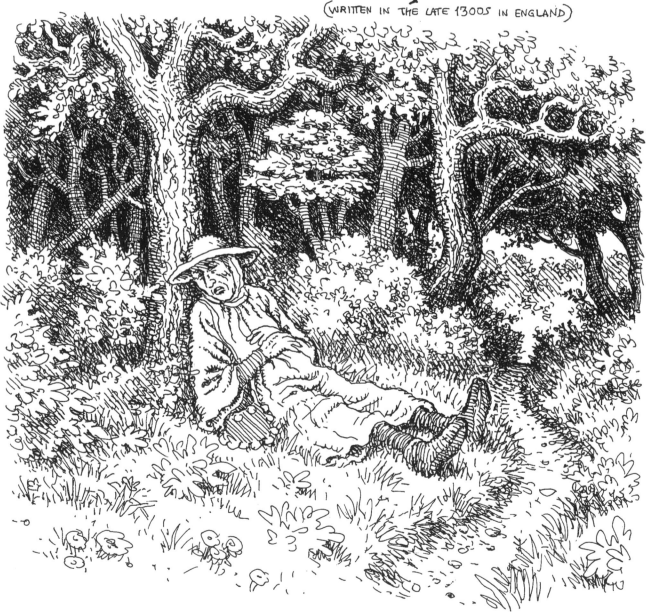

Carol
Vinson
Summer '92
from a photo

BIG CUTE AMAZON
FARM·GIRL SHIKSA THAT
SHE IS....

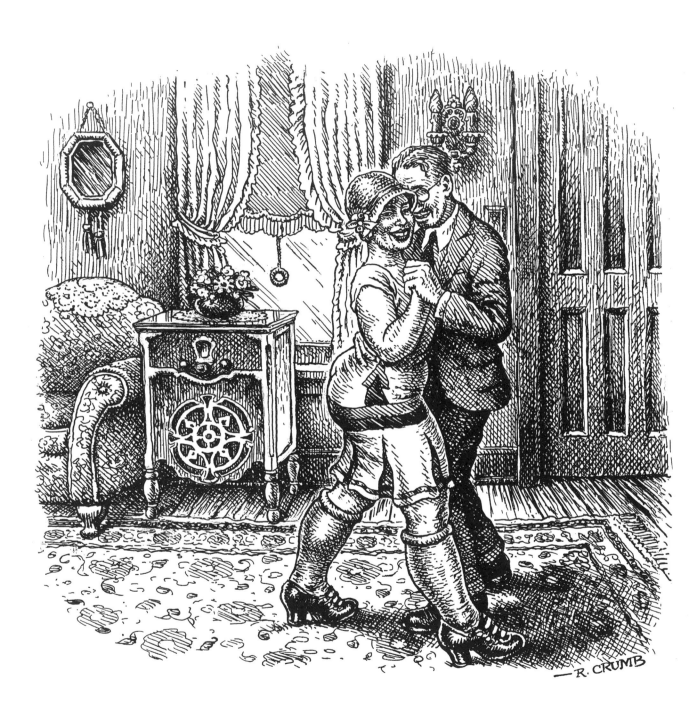

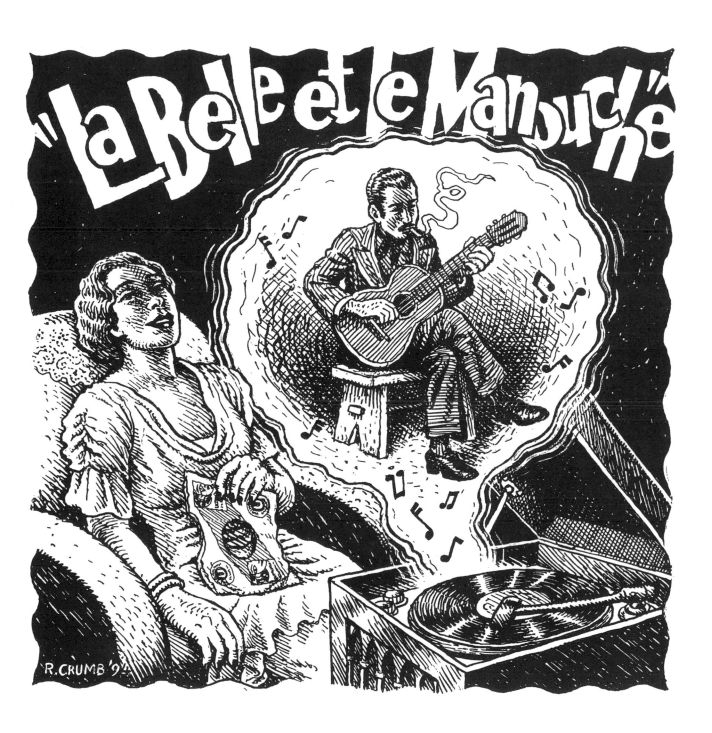

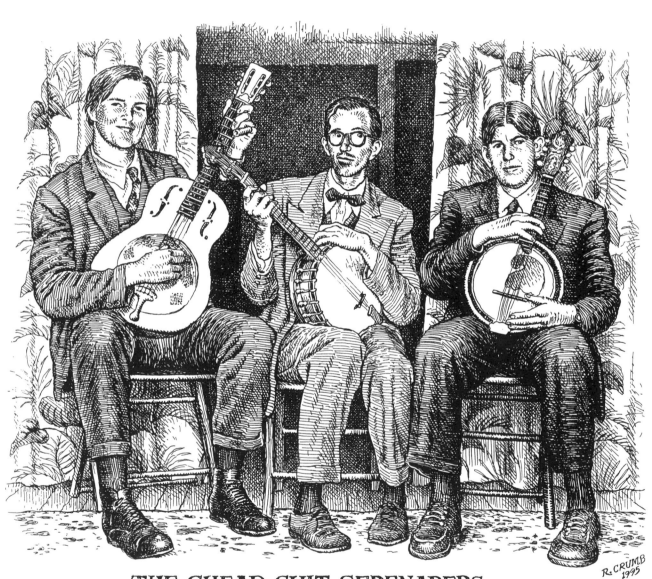

THE CHEAP SUIT SERENADERS
ROBERT ARMSTRONG, R. CRUMB, ALLAN DODGE; DIXON, CALIFORNIA, 1973

R. CRUMB
1995

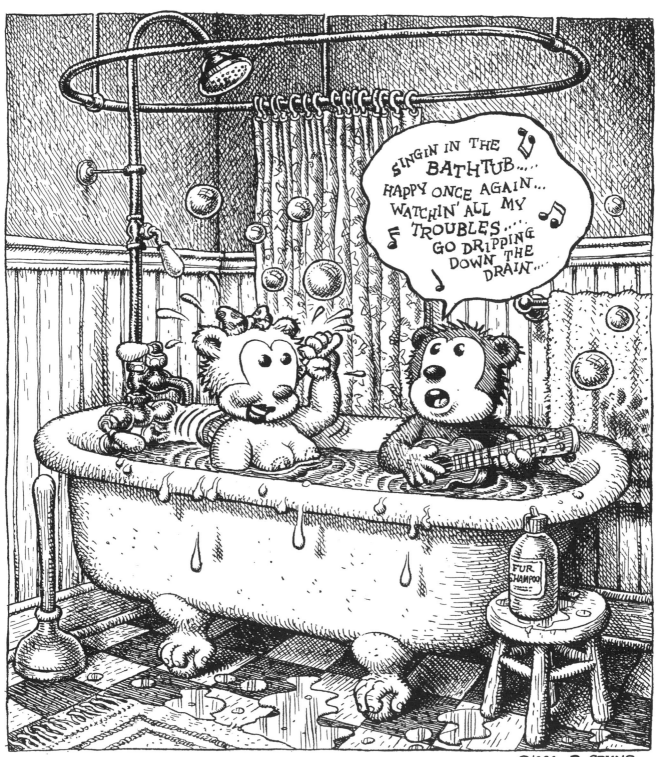

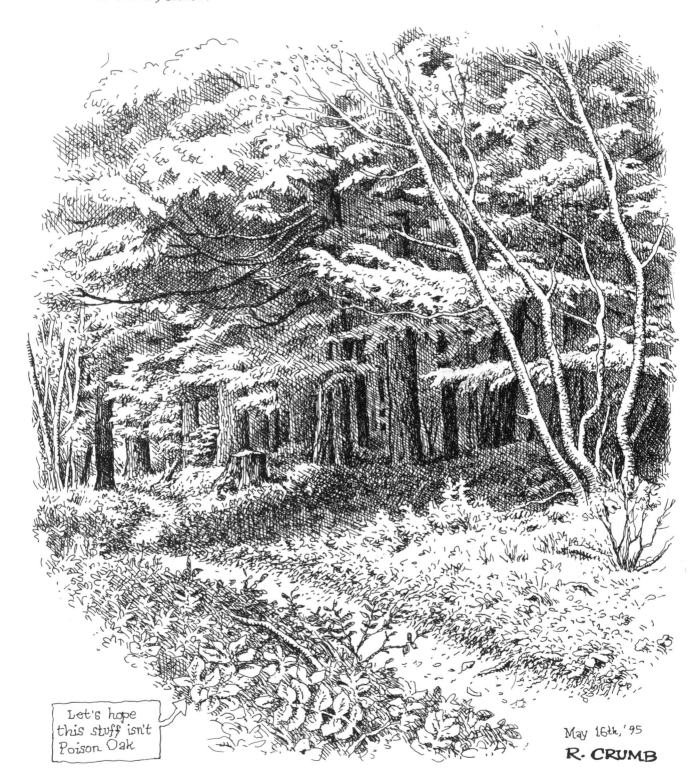

DEAL WITH IT

DEAL WITH IT IN A MANNER PATIENT AND CALM.

ALONG A PATH
IN THE "MER DES ROCHERS"
ABOVE SAUVE

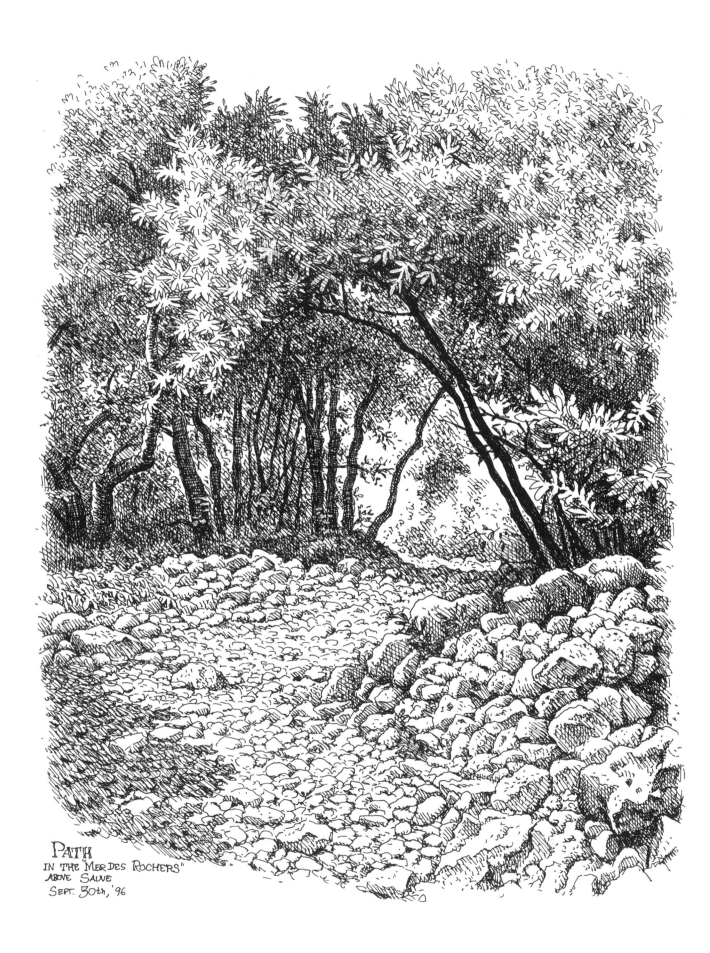

PATH
IN THE "MER DES ROCHERS"
ABOVE SALVE
SEPT. 30th, '96

GETTING AWAY FROM PEOPLE...
MUST BE BACK BY APERITIF TIME...

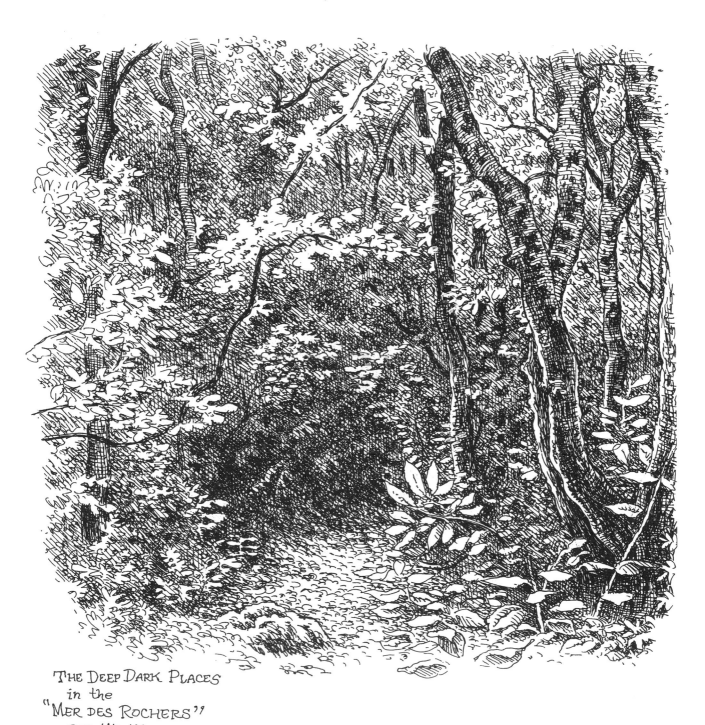

THE DEEP DARK PLACES
in the
"MER DES ROCHERS"
Oct. 11th '96

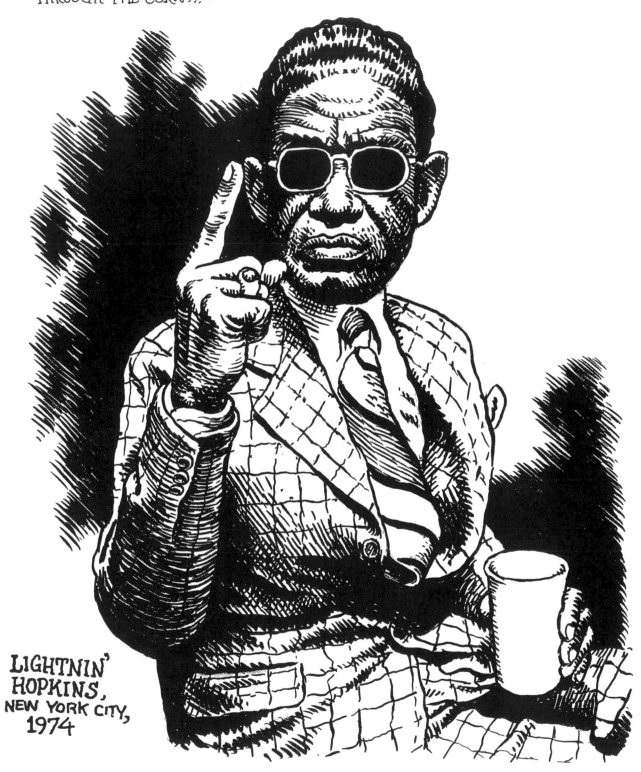

"I'M LONG GONE
LIKE A TURKEY
THROUGH THE CORN..."

LIGHTNIN'
HOPKINS,
NEW YORK CITY,
1974

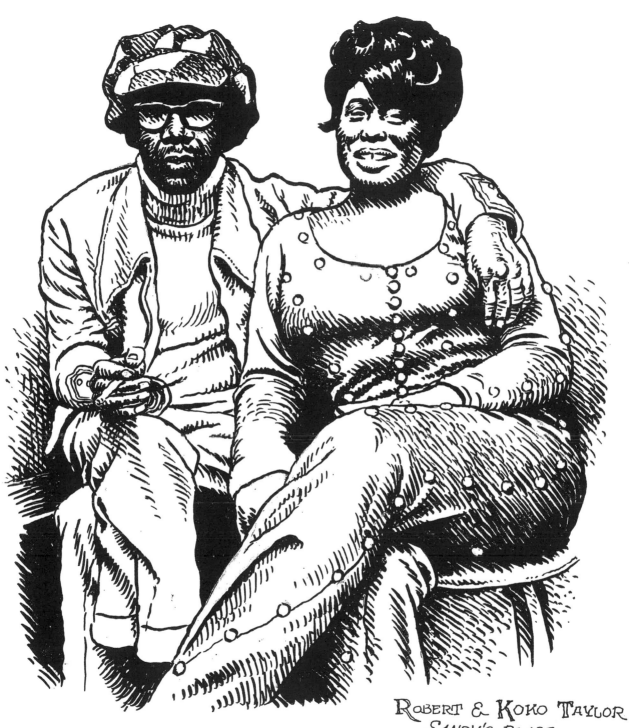

ROBERT & KOKO TAYLOR
SANDY'S PLACE,
BEVERLY, MASS., 1974

SEPT. '97

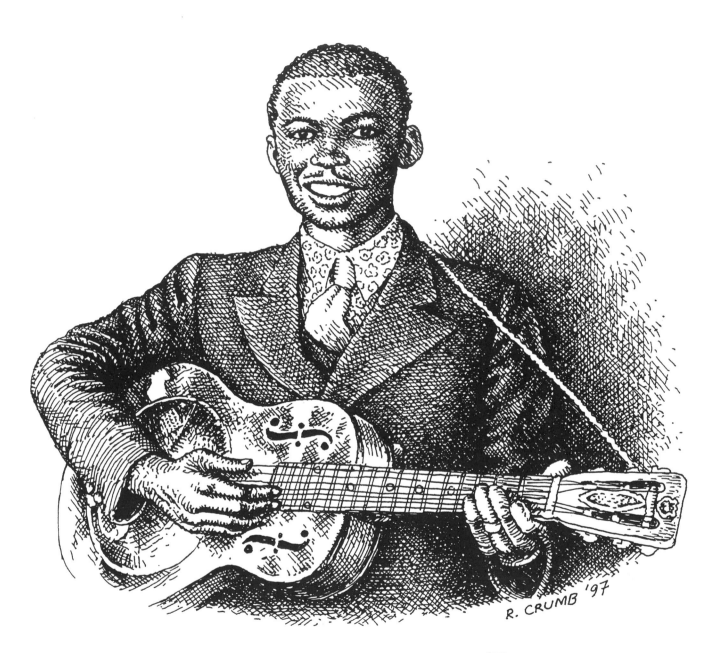

AMOS EASTON
KNOWN AS
"BUMBLE BEE SLIM"

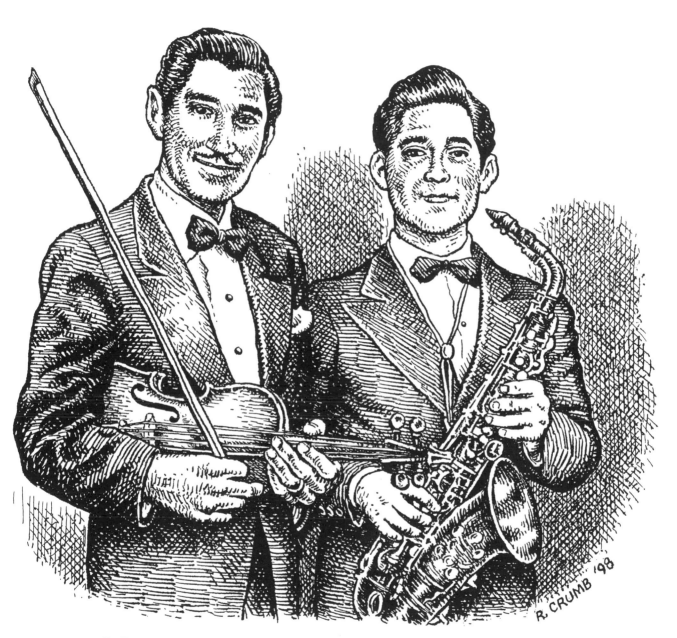

ERNIE & EMILIO CACERES

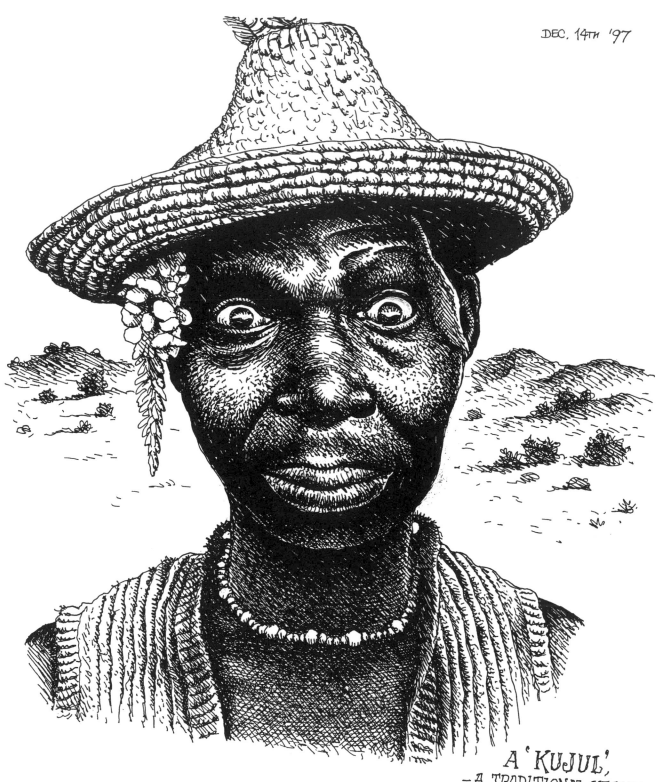

DEC. 14TH '97

A 'KUJUL',
—A TRADITIONAL HEALER—
from the TIRA tribe, one
of fifty NUBA tribes—
Sudan, Africa, 1990s

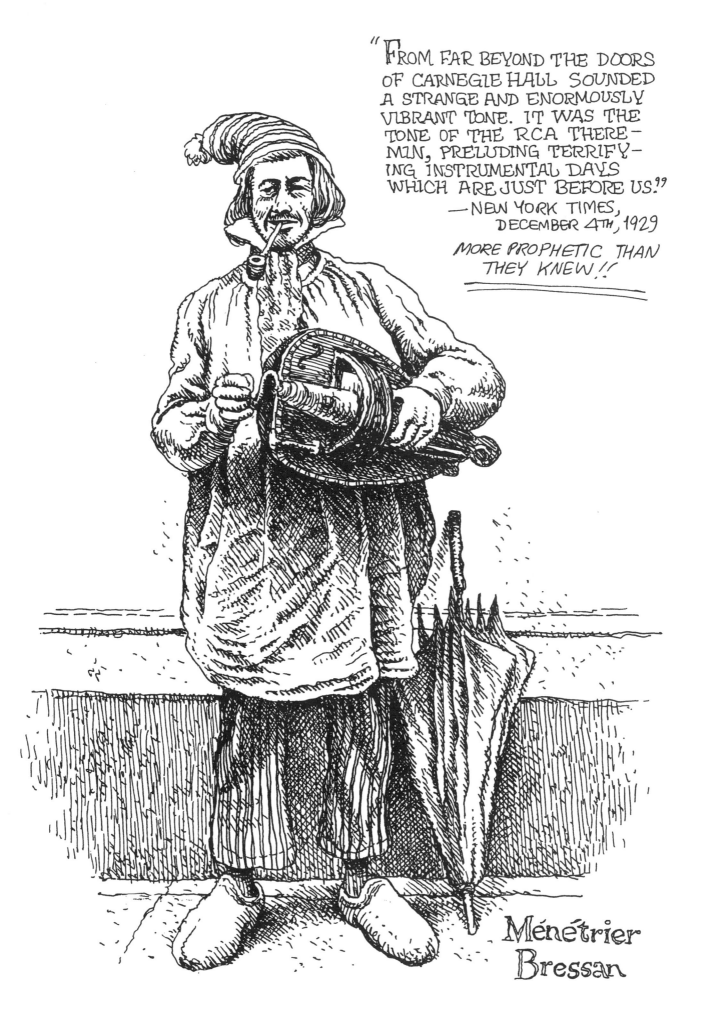

"From far beyond the doors of Carnegie Hall sounded a strange and enormously vibrant tone. It was the tone of the RCA theremin, preluding terrifying instrumental days which are just before us."
— New York Times, December 4th, 1929

More prophetic than they knew!!

Ménétrier Bressan

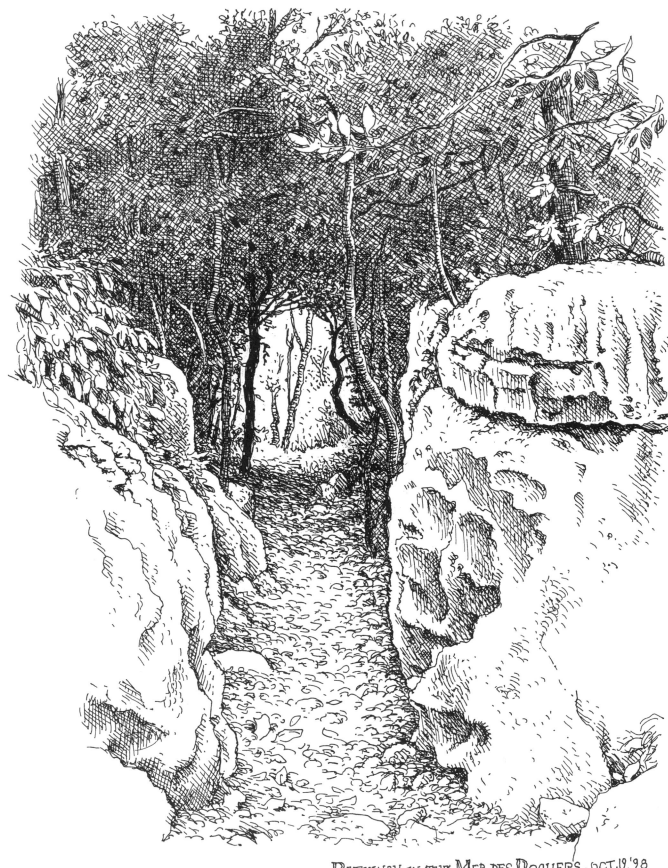

PATHWAY IN THE MER DES ROCHERS · OCT. 19, '98

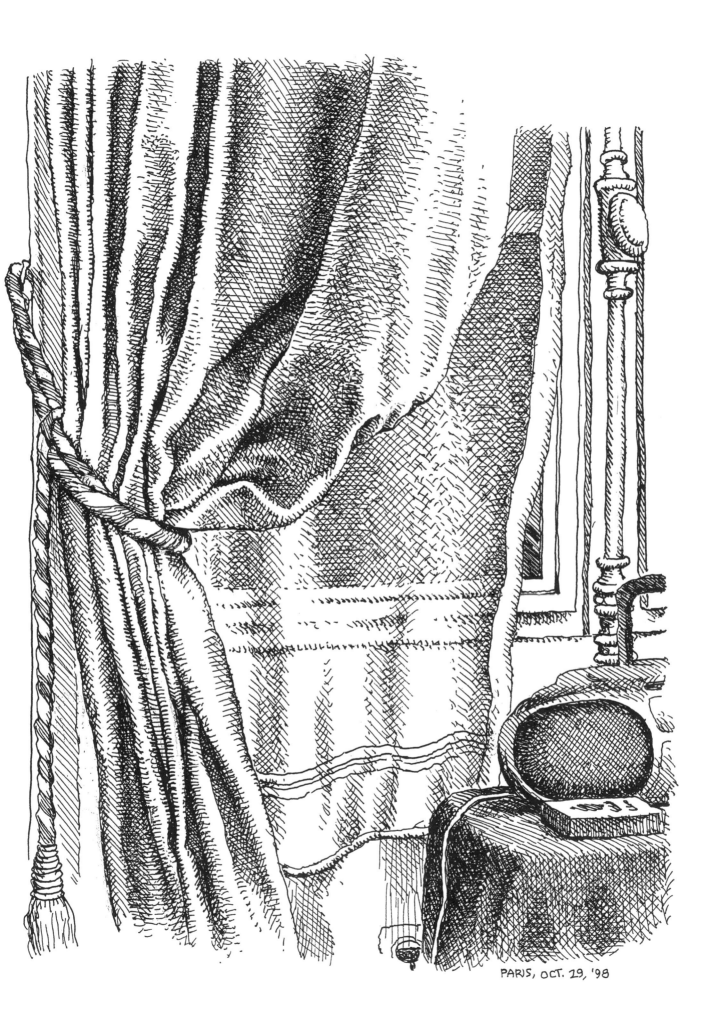

PARIS, OCT. 29, '98

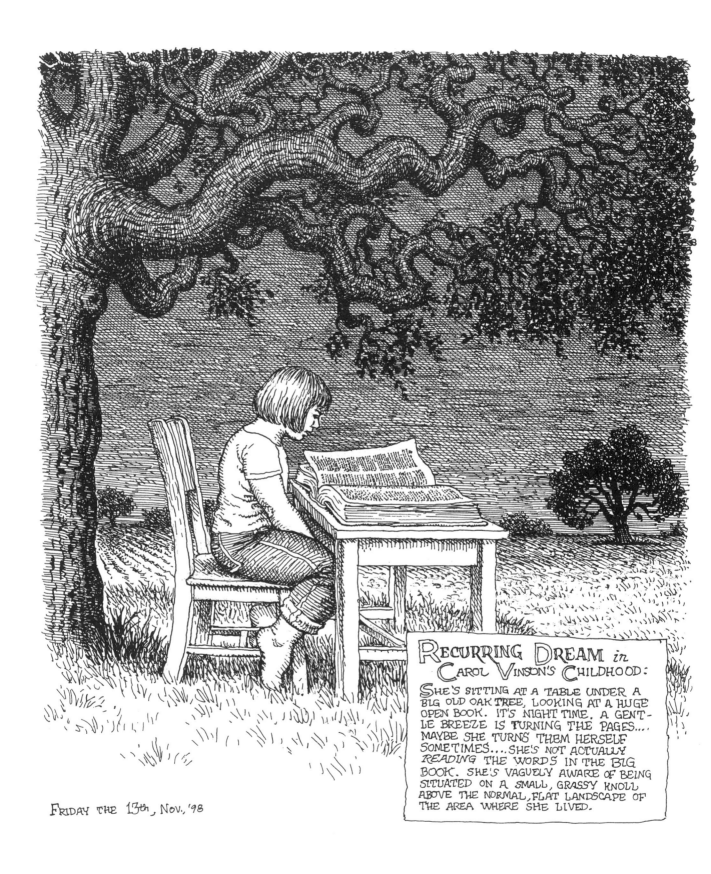

RECURRING DREAM in CAROL VINSON'S CHILDHOOD:

SHE'S SITTING AT A TABLE UNDER A BIG OLD OAK TREE, LOOKING AT A HUGE OPEN BOOK. IT'S NIGHT TIME. A GENTLE BREEZE IS TURNING THE PAGES.... MAYBE SHE TURNS THEM HERSELF SOMETIMES.... SHE'S NOT ACTUALLY *READING* THE WORDS IN THE BIG BOOK. SHE'S VAGUELY AWARE OF BEING SITUATED ON A SMALL, GRASSY KNOLL ABOVE THE NORMAL, FLAT LANDSCAPE OF THE AREA WHERE SHE LIVED.

FRIDAY THE 13th, NOV., '98

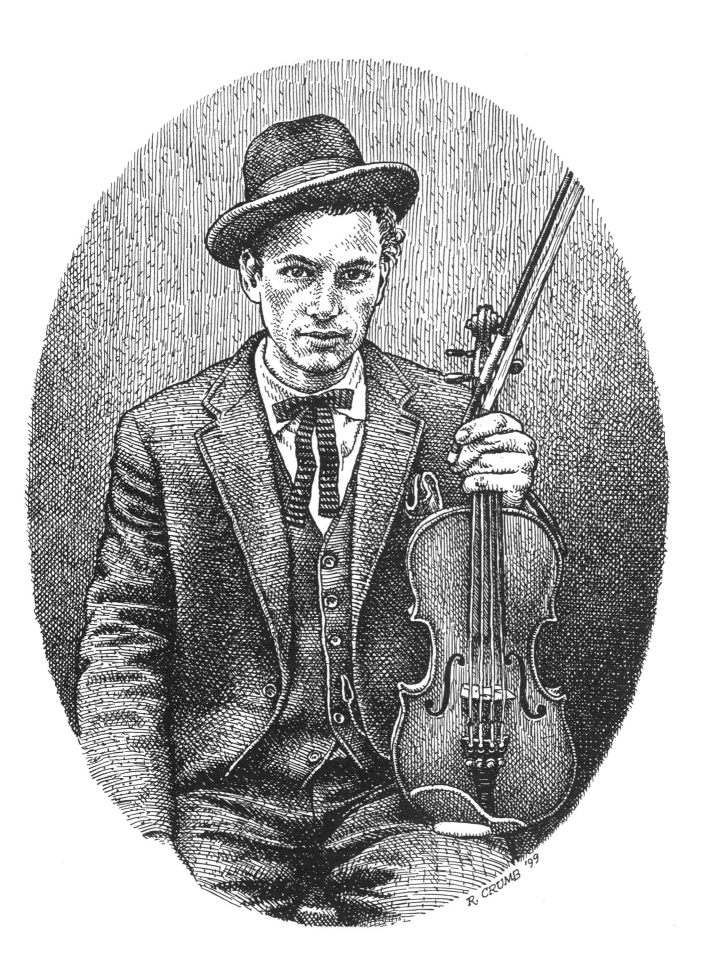

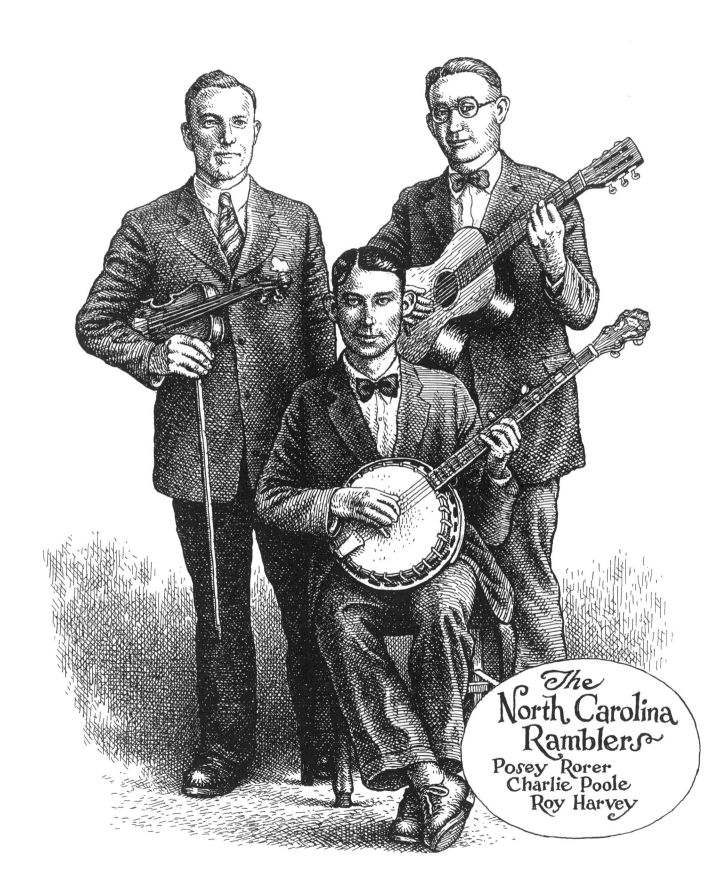

The
North Carolina
Ramblers
Posey Rorer
Charlie Poole
Roy Harvey

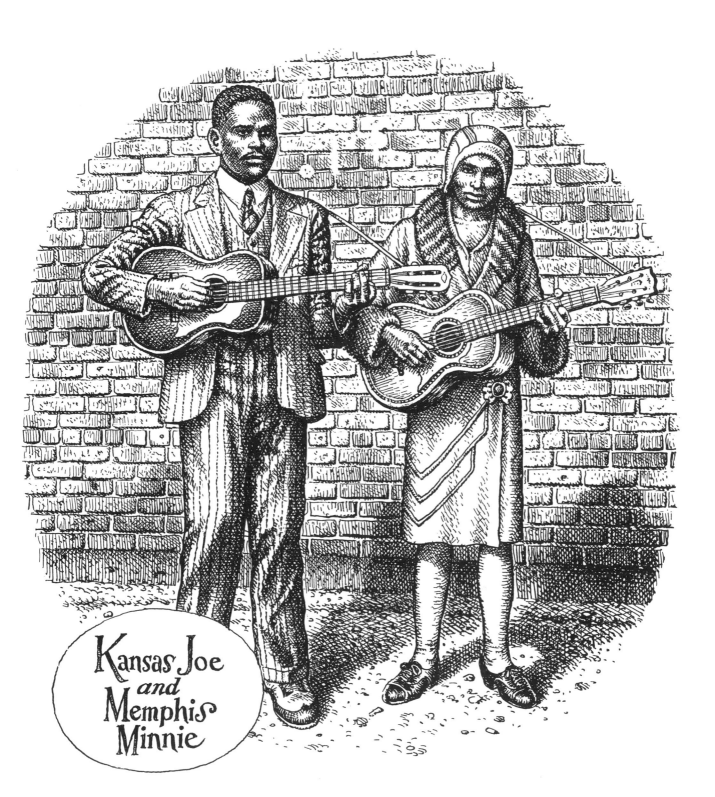

Kansas Joe *and* Memphis Minnie

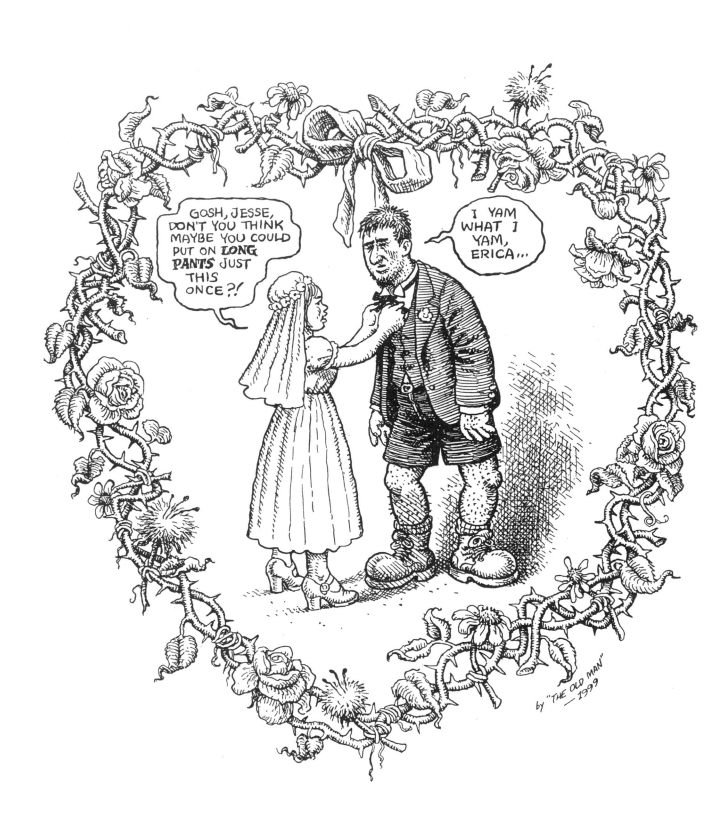

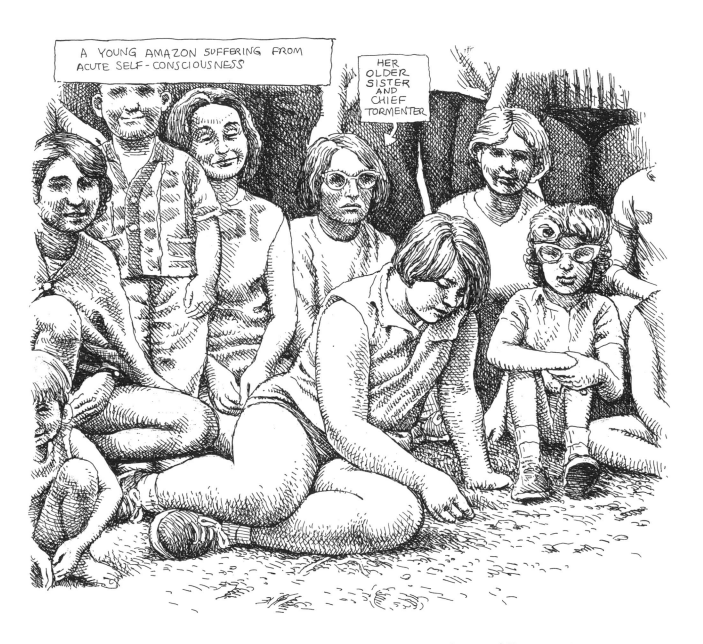

A YOUNG AMAZON SUFFERING FROM ACUTE SELF-CONSCIOUSNESS

HER OLDER SISTER AND CHIEF TORMENTER

SHE HATED THIS PHOTO!

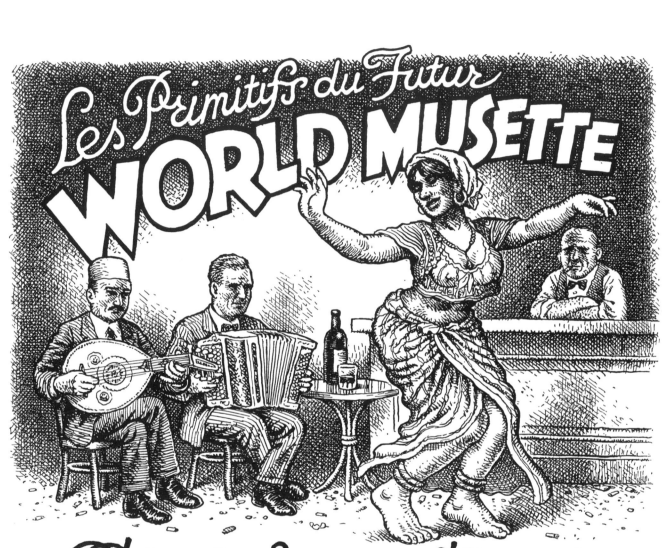

Eternity

I'M TALKIN' ABOUT...

Eternity!

...and that's a long time, children!

ONE LIFETIME AIN'T NOTHIN'....

Eternity~

WE CAN'T GRASP IT...IT'S
JUST A WORD...
....E·T·E·R·N·I·T·Y
THAT'S DEEP...

"GAY LIFE IN DIKANKA"
R. CRUMB'S OLD-TIME FAVORITES

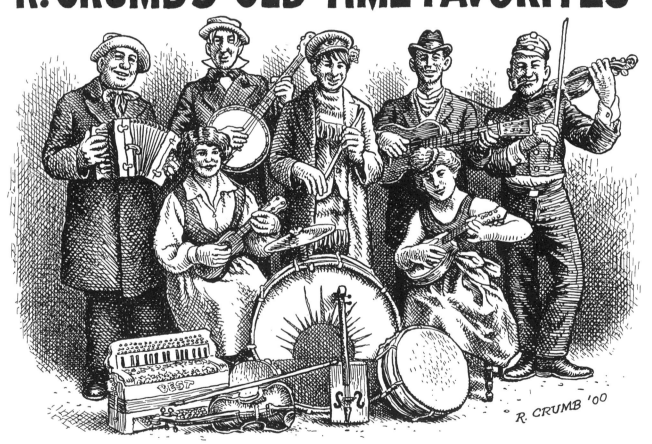

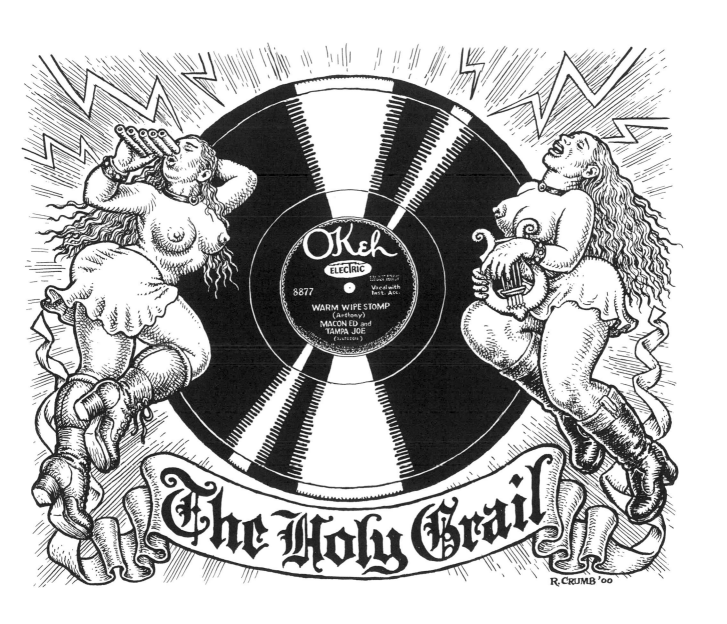

OKeh
ELECTRIC
8877
Vocal with
Inst. Acc.
WARM WIPE STOMP
(Anthony)
MACON ED and
TAMPA JOE

The Holy Grail

R. CRUMB '00

Broken Teapot
It served us well for many years.

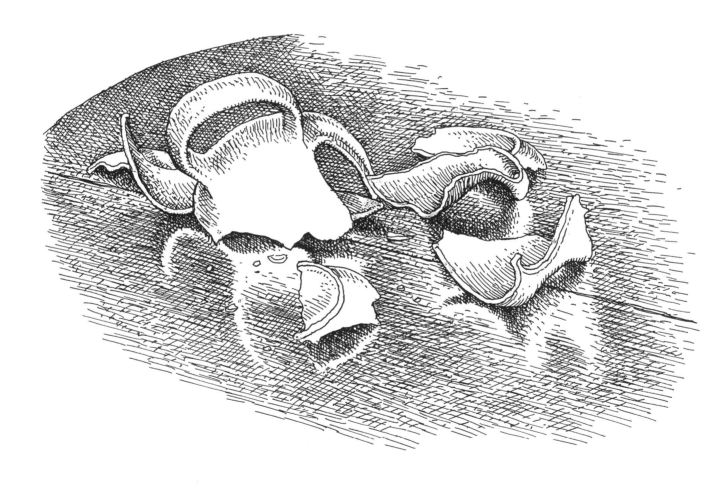

Paris,
Sept. 23rd '00

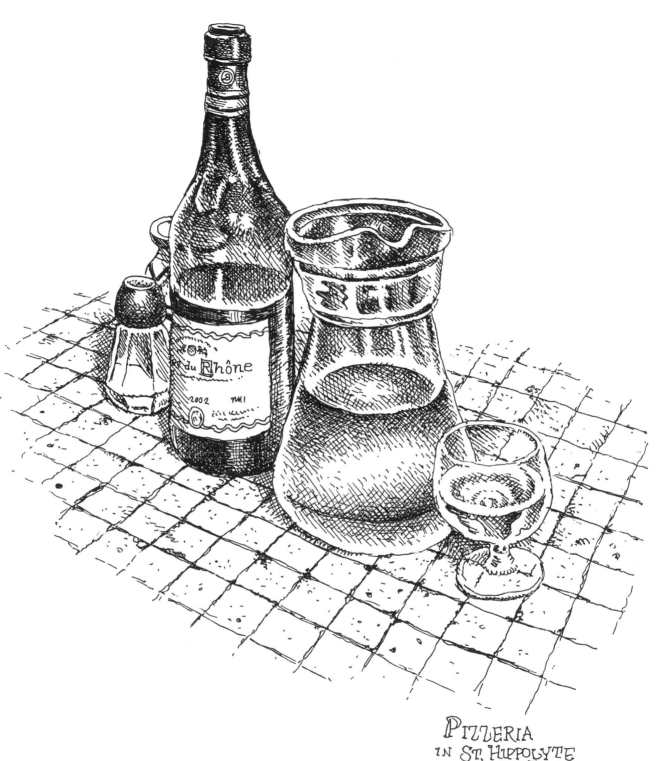

PIZZERIA
IN ST. HIPPOLYTE
DU FORT

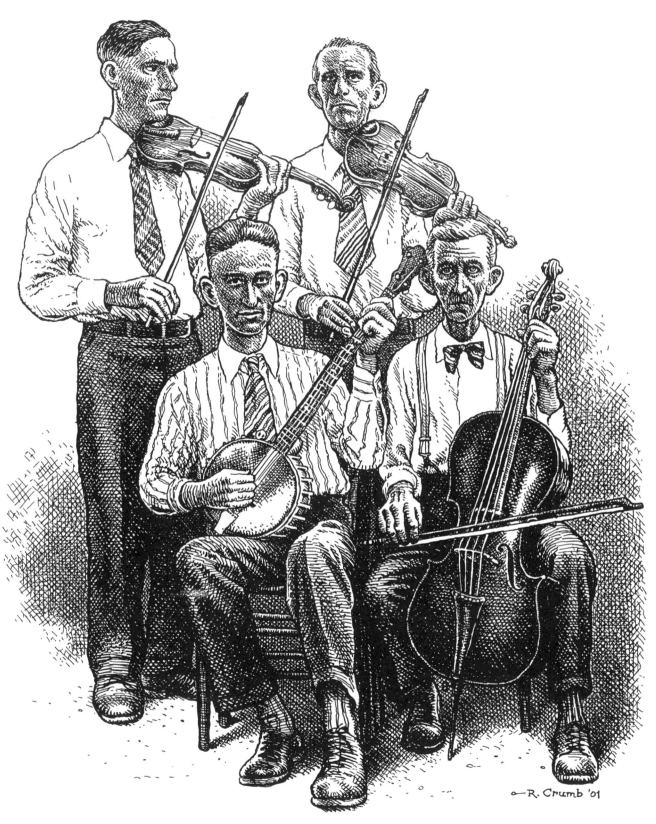

WEEMS STRING BAND

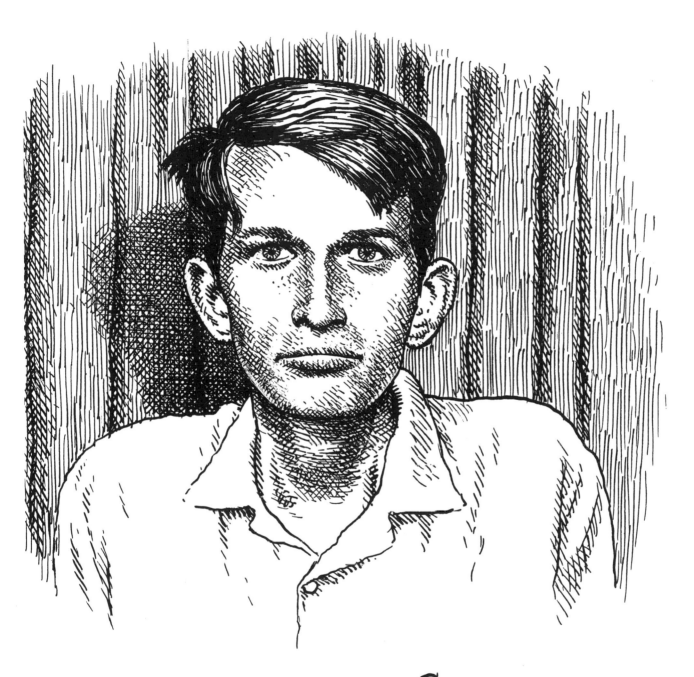

CHARLES
CRUMB JR.
FROM A 25·CENT
PHOTO-BOOTH PHOTO,
1963 — HE WAS 21
YEARS OLD,

JULY 24TH, 2001

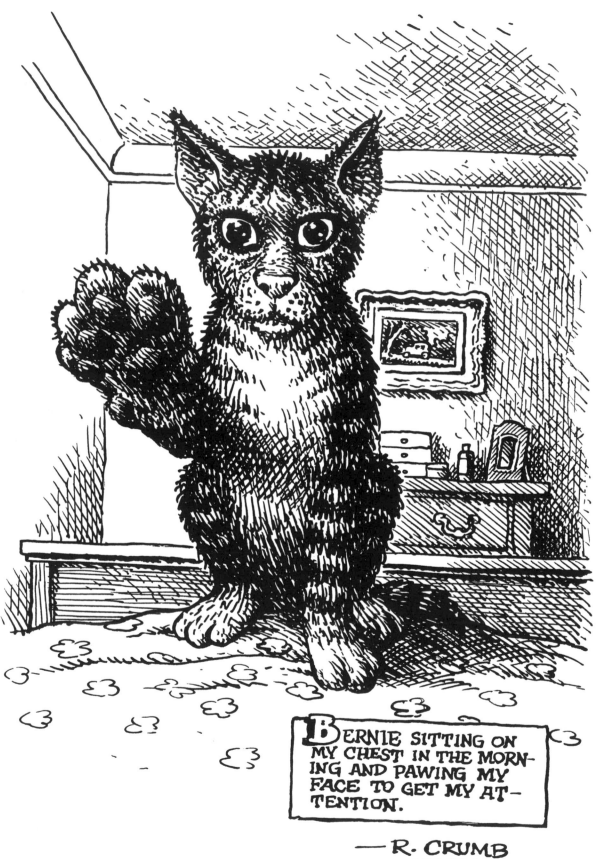

BERNIE SITTING ON MY CHEST IN THE MORNING AND PAWING MY FACE TO GET MY ATTENTION.

— R. CRUMB
AUGUST '01

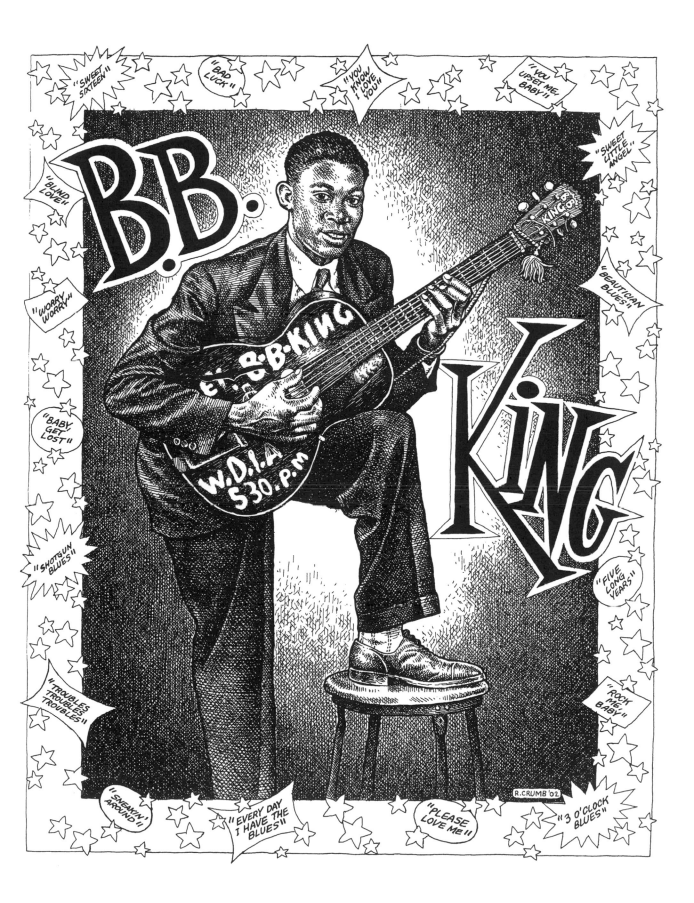

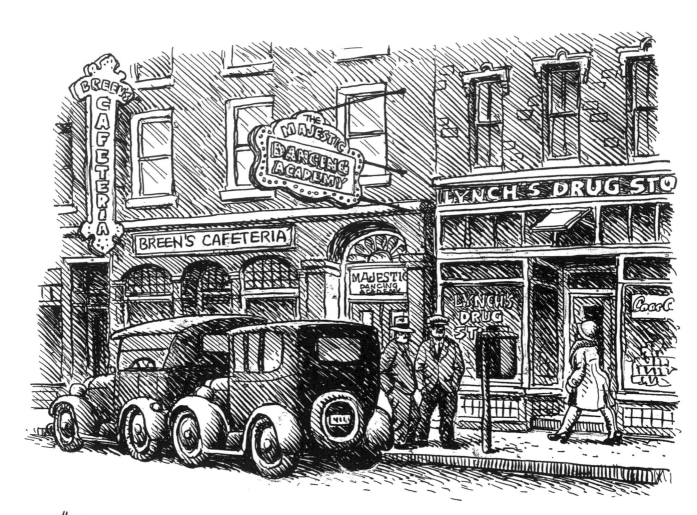

"IN CHICAGO, WITH WHICH THIS STUDY IS CHIEFLY CONCERNED, THE TAXI-DANCE HALLS ALMOST INVARIABLY SEEM TO HAVE INCORPORATED THE NAME "DANCING SCHOOL" OR "DANCING ACADEMY" INTO THEIR TITLE AS THOUGH TO SUGGEST THAT SYSTEMATIC INSTRUCTION IN DANCING WERE GIVEN.

IN THESE HALLS YOUNG WOMEN AND GIRLS ARE PAID TO DANCE WITH ALL COMERS. THE GIRL IS EXPECTED TO DANCE WITH ANY MAN WHO MAY CHOOSE HER AND TO REMAIN WITH HIM ON THE DANCE FLOOR FOR AS LONG A TIME AS HE IS WILLING TO PAY THE CHARGE. HENCE THE SIGNIFICANCE OF THE APT. NAME "TAXI-DANCER." LIKE THE TAXI-DRIVER WITH HIS CAB, SHE IS FOR PUBLIC HIRE AND IS PAID IN PROPORTION TO THE TIME SPENT AND THE SERVICES RENDERED;"

— THE TAXI DANCE HALL
BY PAUL G. CRESSEY
"A SOCIOLOGICAL STUDY IN COMMERCIALIZED RECREATION AND CITY LIFE"
— CHICAGO, ILLINOIS, 1932

1920s TYPES

FROM MICHAEL LESY'S BOOK
"REAL LIFE - LOUISVILLE
IN THE TWENTIES"

GIRLS
FROM
SCHOOL
GROUP
PHOTO
I FOUND
SOMEWHERE

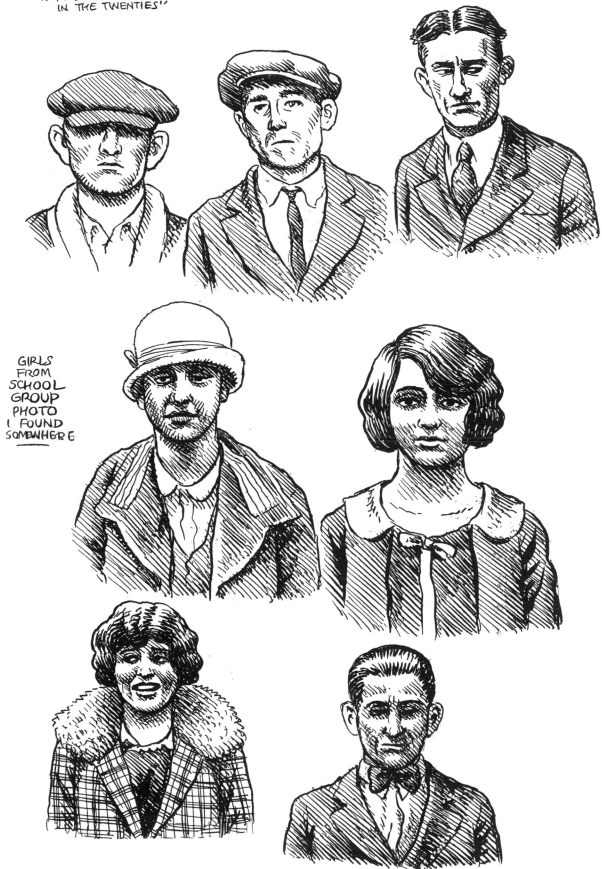

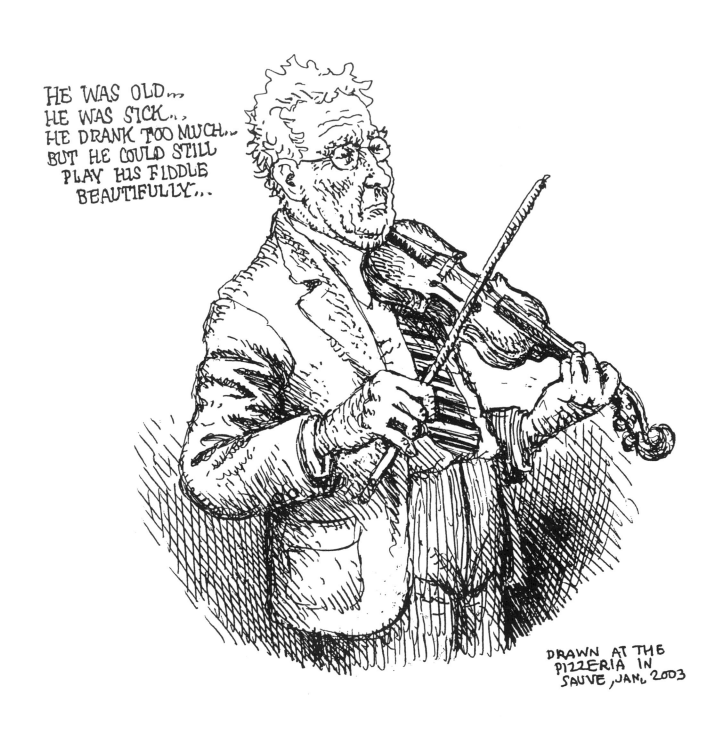

HE WAS OLD...
HE WAS SICK...
HE DRANK TOO MUCH...
BUT HE COULD STILL
PLAY HIS FIDDLE
BEAUTIFULLY...

DRAWN AT THE
PIZZERIA IN
SAUVE, JAN. 2003

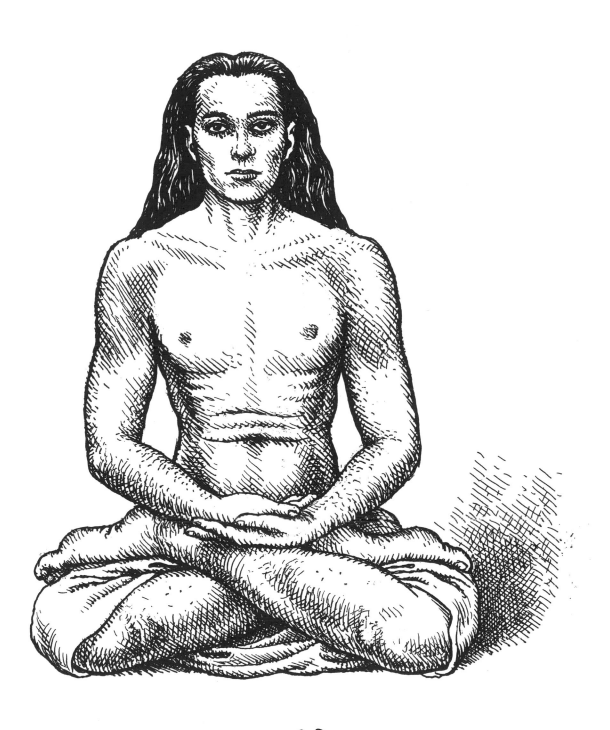

BABAJI
A Mahavatar, "Divine Incarnation"
"Mahavatar Babaji has refused to reveal to his disciples any limiting facts about his birthplace and birth date. He has lived for many centuries amid the Himalayan snows."

—Copied from a drawing in
AUTOBIOGRAPHY OF A YOGI by YOGANANDA

—Feb. 2, '03

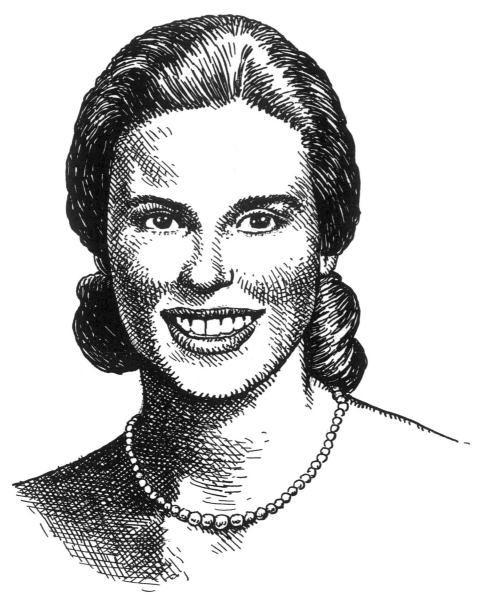

Lillian Elizabeth Burris

"Lilla... if ever you are in need
of a friend, you can always depend
on Lilla... plans to attend college."

Hockey 1,2,3,4; Basketball 1,2,3,4;
Student Council 2,4; Class Officer
1,3; Honor Society 3,4; Junior
Play; Athletic Association 3.

— Milfordian,
 Milford High School
 Year Book, 1961

Copied from Senior
Class Photo,
 August 27, 2003

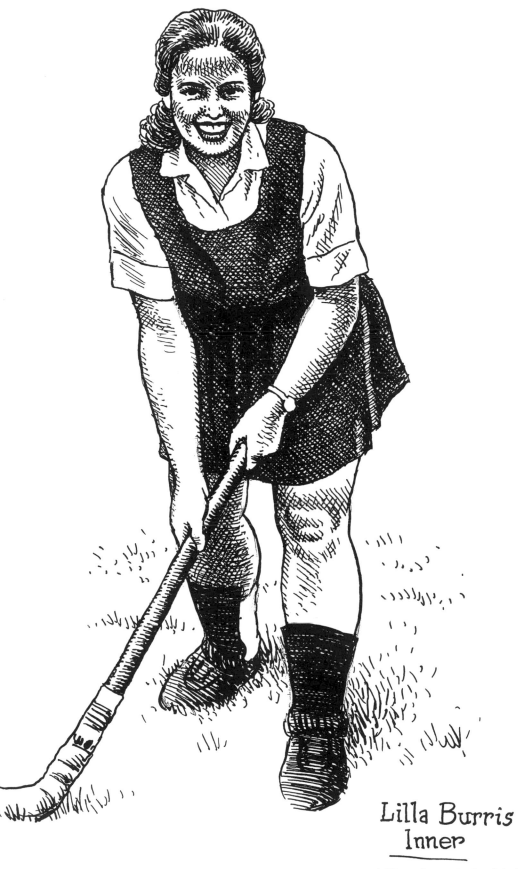

Lilla Burris
Inner

MILFORDIAN, 1961

AUGUST 27, '03

DANGA AND ELIZABETH BURRIS WERE CLOSE FRIENDS. THEY WERE ALWAYS TOGETHER. THEY WERE THE BIG GIRLS OF OUR CLASS. BOTH OF THEM WERE VERY BIG, TALL AND ATHLETIC, BOTH WERE VERY GOOD STUDENTS, AT THE TOP OF THE CLASS. ELIZABETH BURRIS WAS A BIT MORE POPULAR THAN DANGA. DANGA WASN'T AS GOOD LOOKING AS "LILLA", AND WAS HEAVIER, THICKER. SHE WAS SHY, DISTANT, BUT ALWAYS POISED, FRIENDLY IN A RATHER PASSIVE, IMPERSONAL WAY. I DON'T RECALL EVER SEEING HER WITH A BOY, OR EVEN *TALKING* TO A BOY. SHE AND ELIZABETH BURRIS WERE ACTIVE IN EVERY ATHLETIC GAME AVAILABLE TO GIRLS AT THAT TIME. DANGA WAS WHAT WOULD BE CALLED NOWADAYS A TOTAL "JOCK" GIRL.

WITH THESE TWO AMAZONS ON THE GIRLS' HOCKEY AND BASKET-BALL TEAMS, MILFORD BEAT EVERY OTHER GIRL'S HIGHSCHOOL TEAM THEY PLAYED AGAINST!

THEY ALSO HAD, ON THE BASKETBALL TEAM, THE FIERCE, POWERFUL NINTH GRADE AMAZON SUSAN KIRBY!

DANGA WAS VOTED "MOST ATHLETIC" GIRL IN THE SENIOR CLASS.

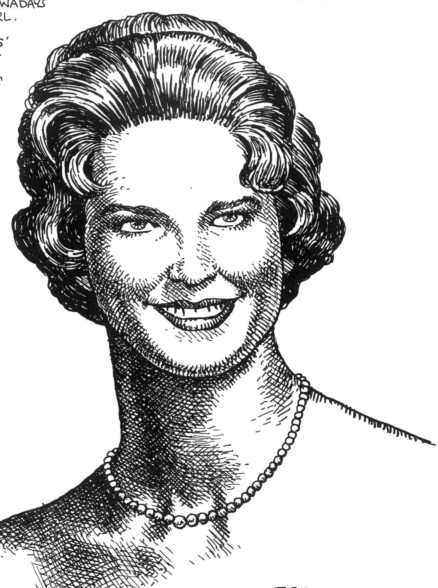

Danga Vileisis

"...swings a mean hockey stick... 'Shoot!'... our future Ice Folly queen ...always neat in her appearance."

— MILFORDIAN

MILFORD HIGH SCHOOL YEARBOOK, 1961
MILFORD, DELAWARE

(DRAWN FROM OFFICIAL SENIOR CLASS PHOTO)

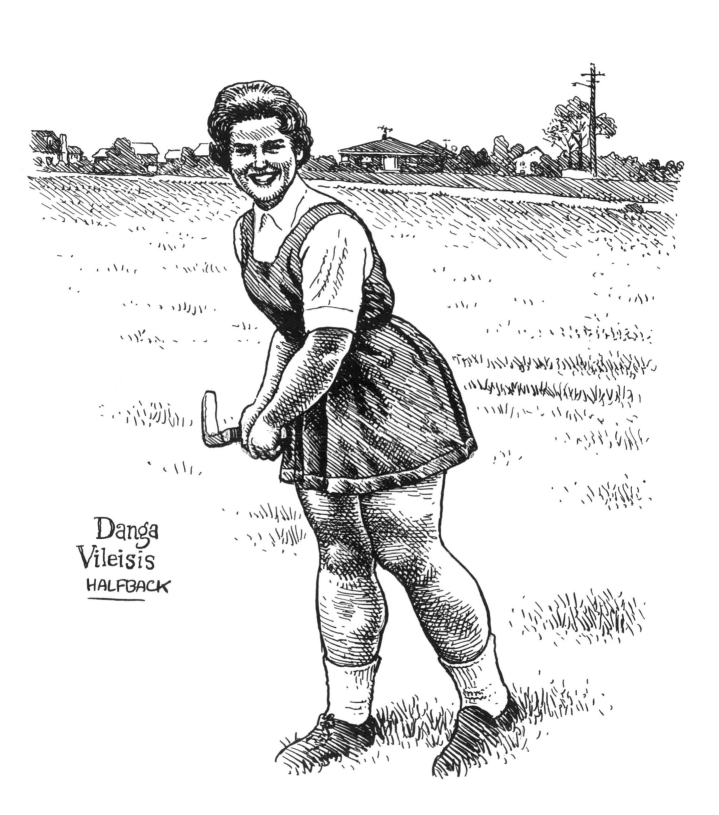

Danga
Vileisis
HALFBACK

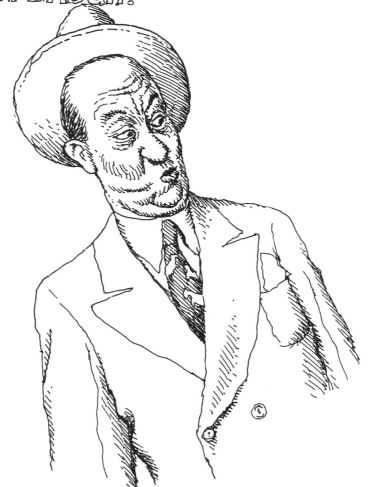

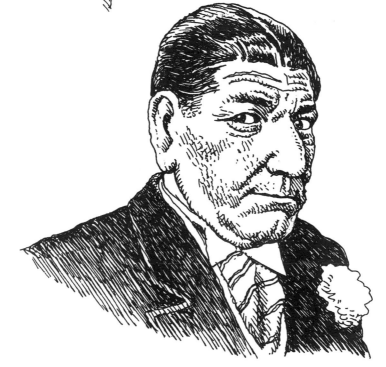

DARK-BLUE AND
LIGHT GRAY JACKET

OCEANSIDE,
CALIFORNIA,
JUNE, 1953
R. CRUMB
RECEIVES EARLY
"POSITIVE REIN-
FORCEMENT" FOR
HIS ARTWORK;
FROM A NEWS PHOTO
TAKEN AT AWARD
CEREMONY, WHERE
HE AND 23 OTHER
STUDENTS WERE
AWARDED PRIZES
IN MERCHANDISE
AND GOVERNMENT
BONDS FOR ENTRIES
SUBMITTED IN OCEAN-
SIDE- CARLSBAD
HUMANE SOCIETY'S
POSTER CONTEST.
R.'S POSTER SHOWED
A BIRD AND A WOODEN
BIRDHOUSE IN A WINTER
SETTING WITH LARGE
LETTERS SAYING, "BE
KIND TO BIRDS IN
WINTER." R. RECEIVED
A 25-DOLLAR U.S. GOV-
ERNMENT BOND. R.'S
FATHER SAID IT WAS
THE WOOD-GRAIN EF-
FECT ON THE BIRDHOUSE
THAT PUT THE POSTER
ACROSS. R. WAS SO
PROUD.

DEC. 20, '02

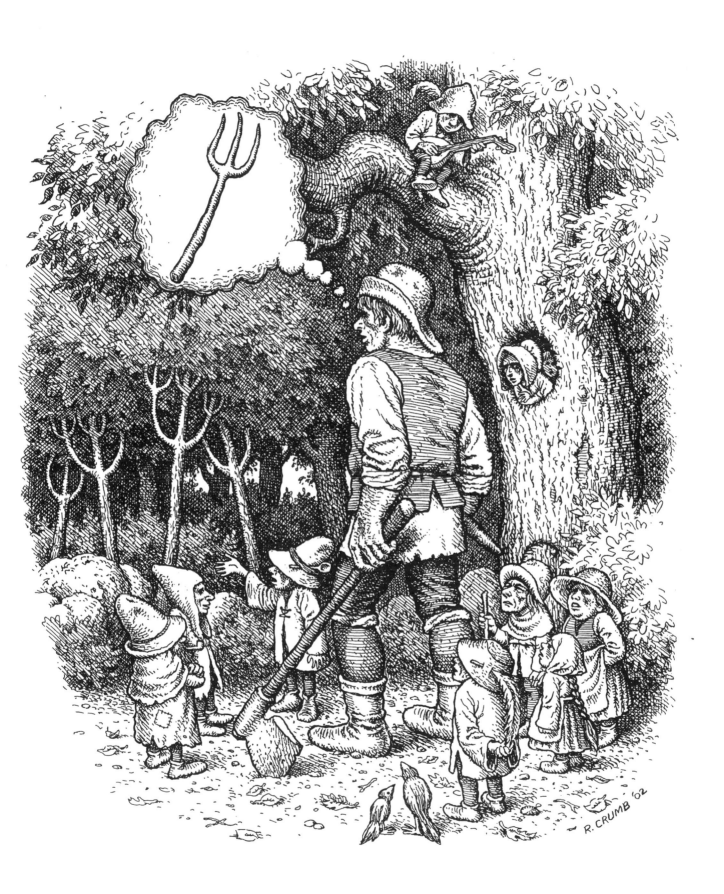

WOMAN WITH
LARGE WHITE DOG
WAITING TO SEE THE
VETERINARIAN....
DEC. 16, '02

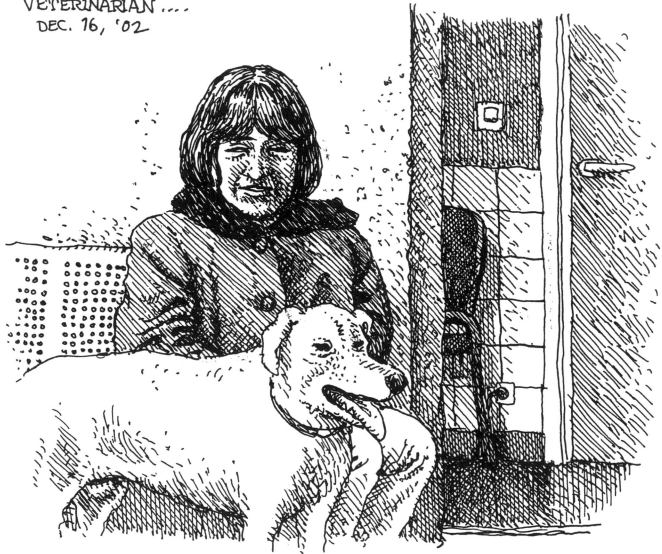

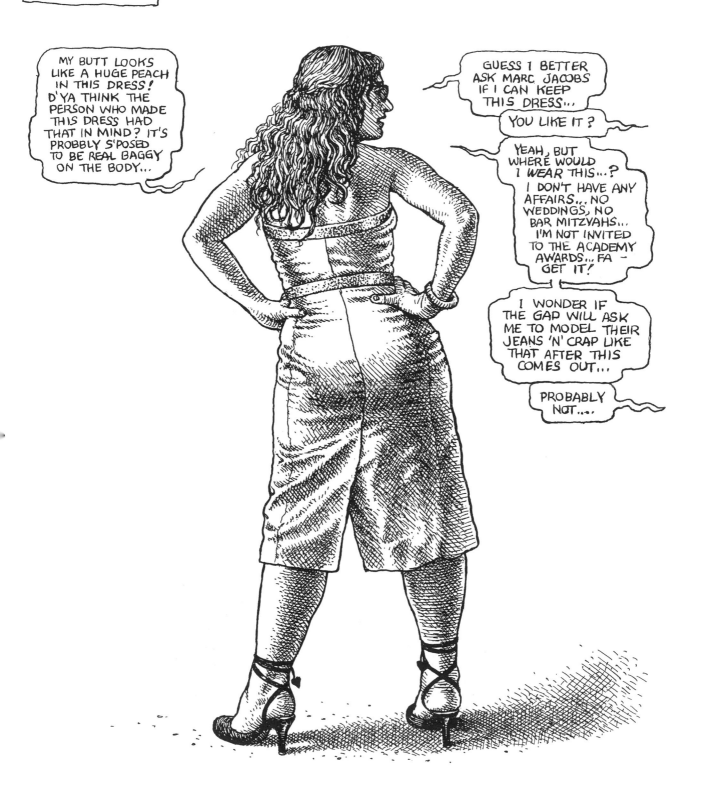

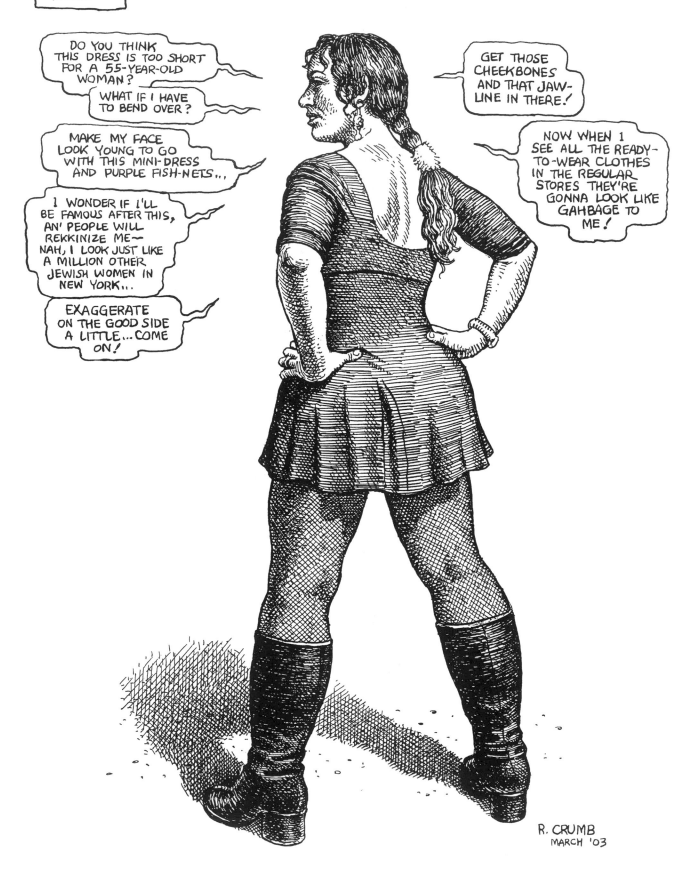

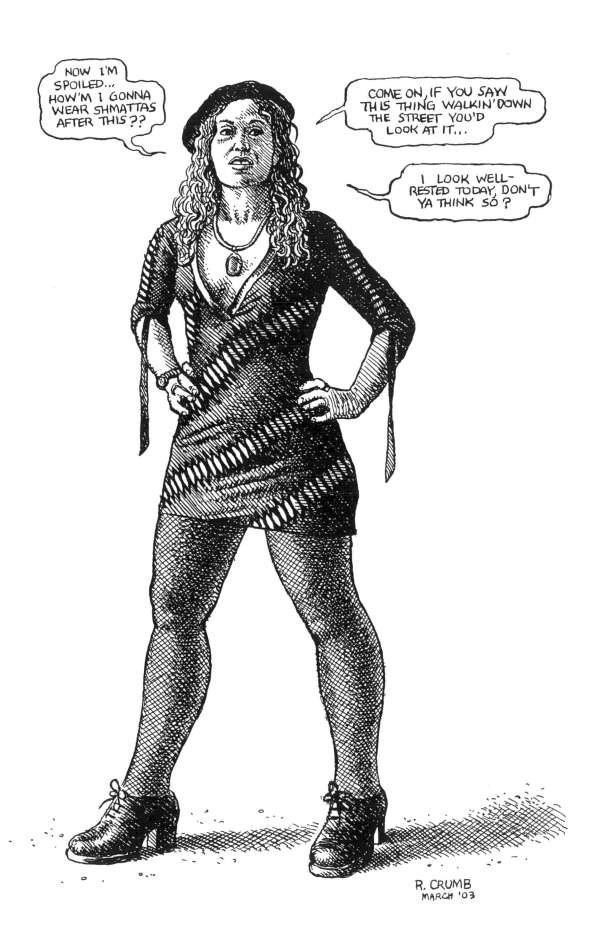

CORNER OF
HOTEL ROOM,
ST. FLOUR,
Jan. 30, '04

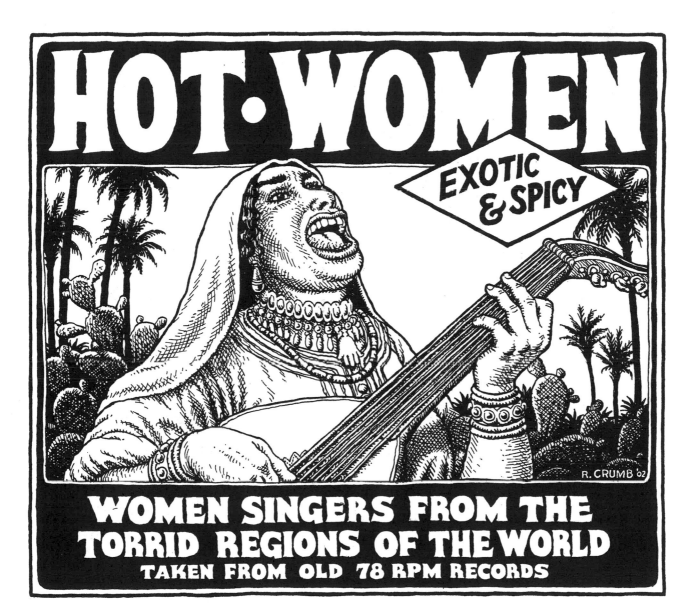

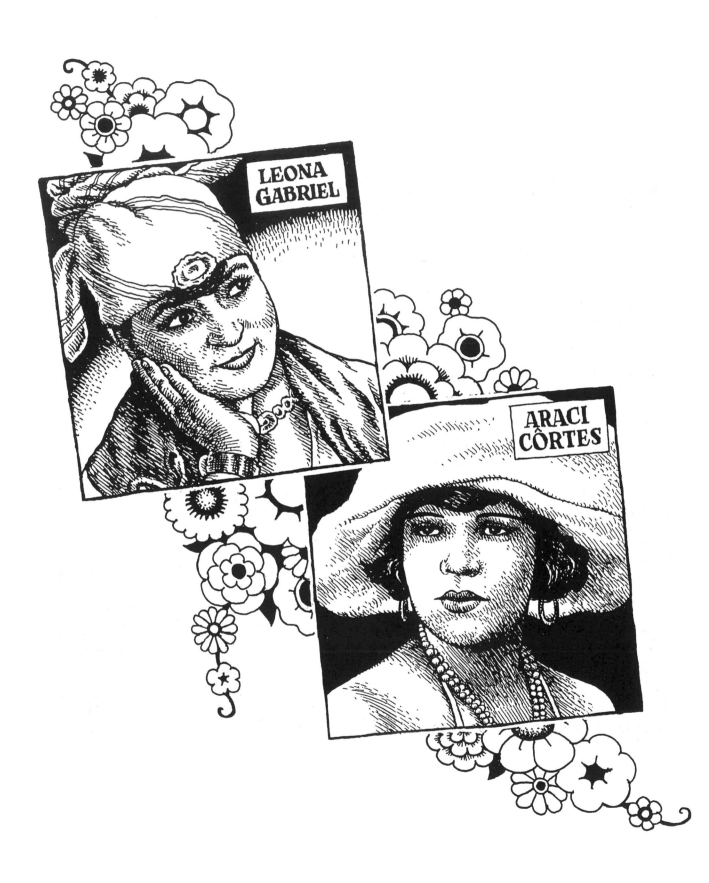

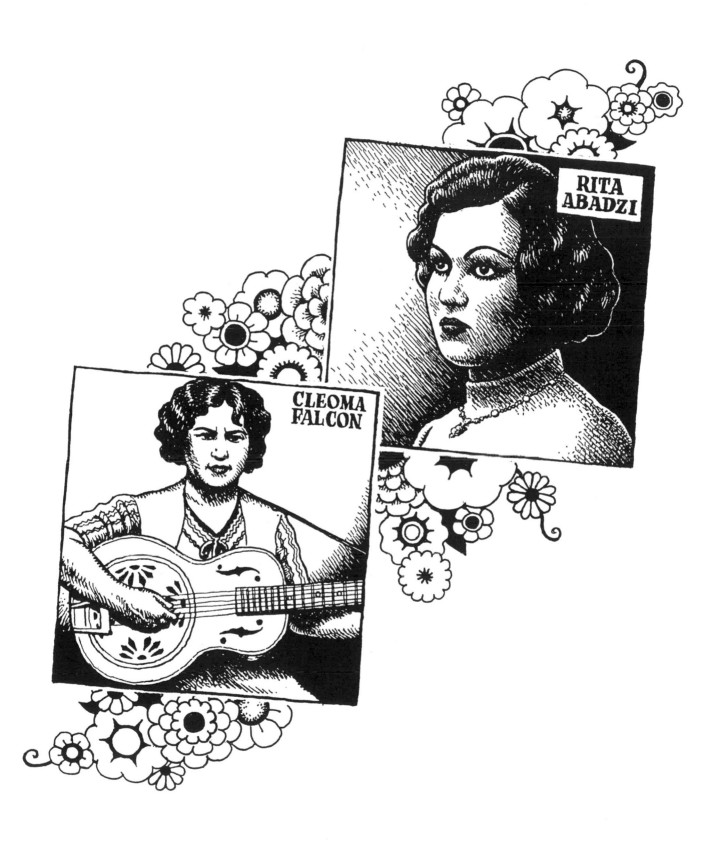

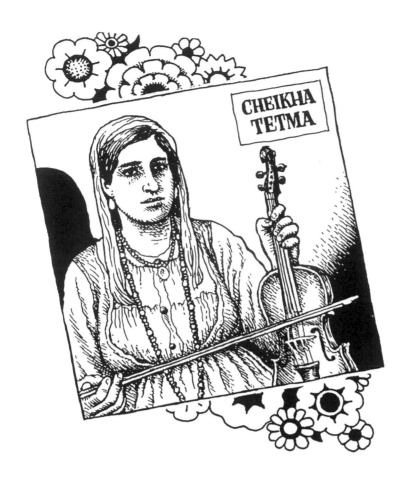

CHEIKHA
TETMA

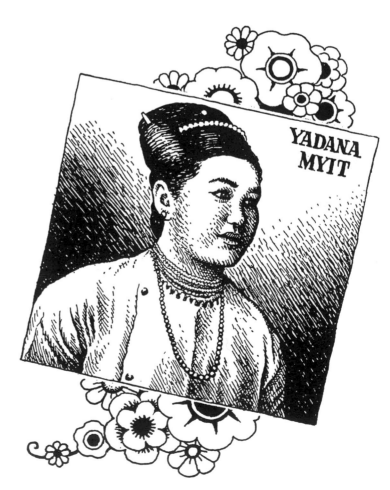

YADANA
MYIT

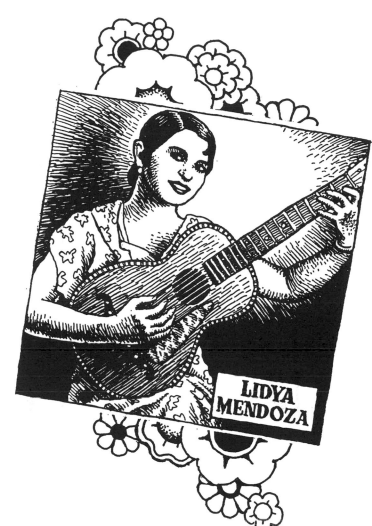

LIDYA
MENDOZA

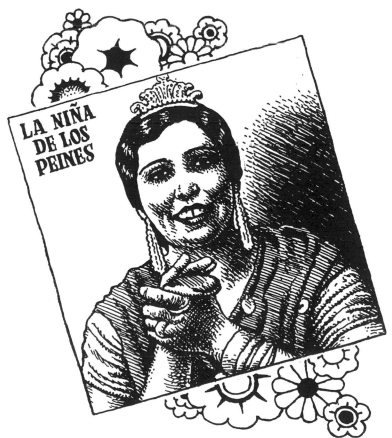

LA NIÑA
DE LOS
PEINES

ZOOT WOMAN

AIR

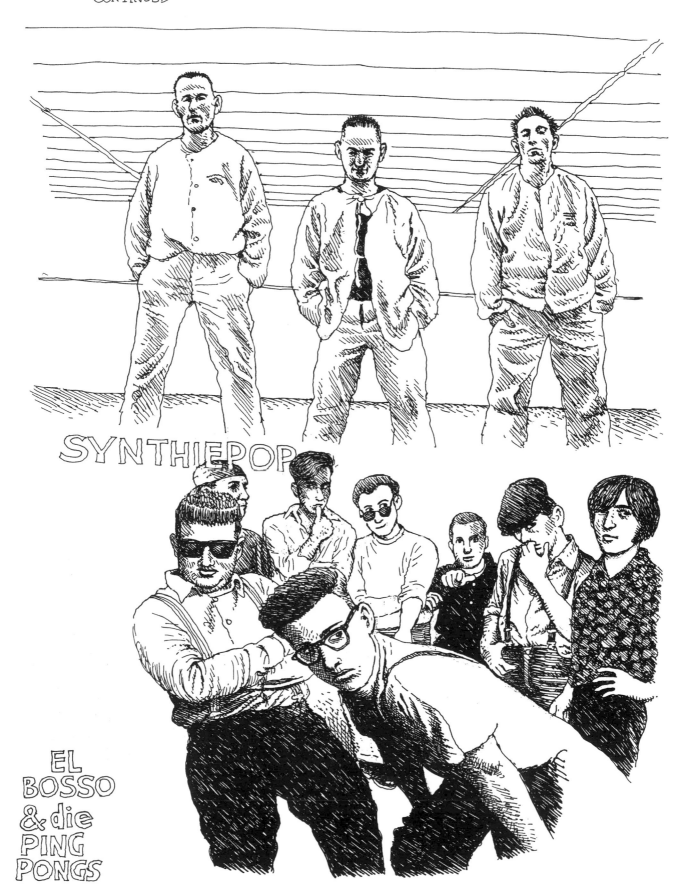

SYNTHIEPOP

EL
BOSSO
& die
PING
PONGS

DRAW YOUR WAY OUT!

COUSIN
DAVE
CRUMB
AGE 16
from photo in
CRUMB NEWS
VOLUME 11, ISSUE 1
DECEMBER, 2003
from
Stillwater, Minnesota

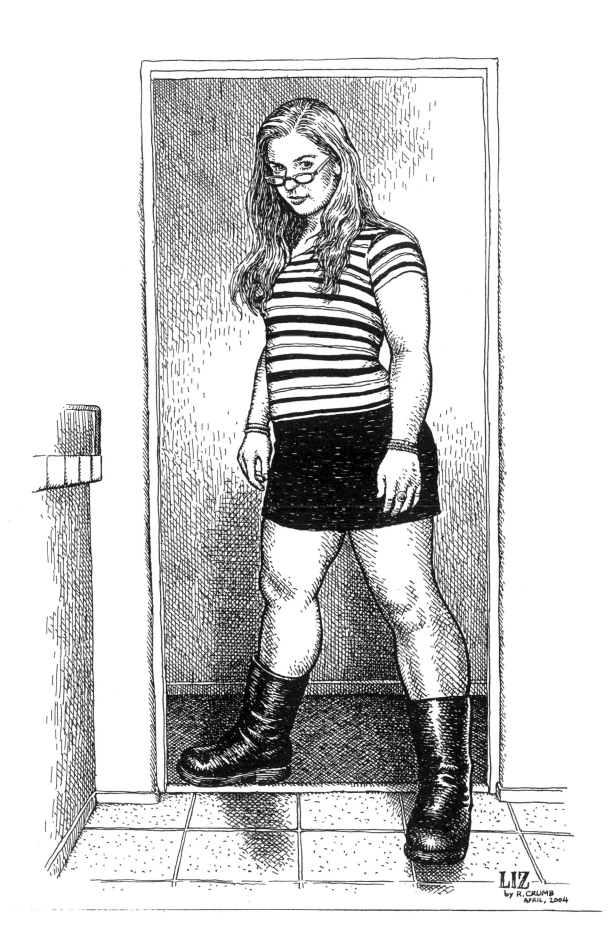

LIZ
by R. CRUMB
APRIL, 2004

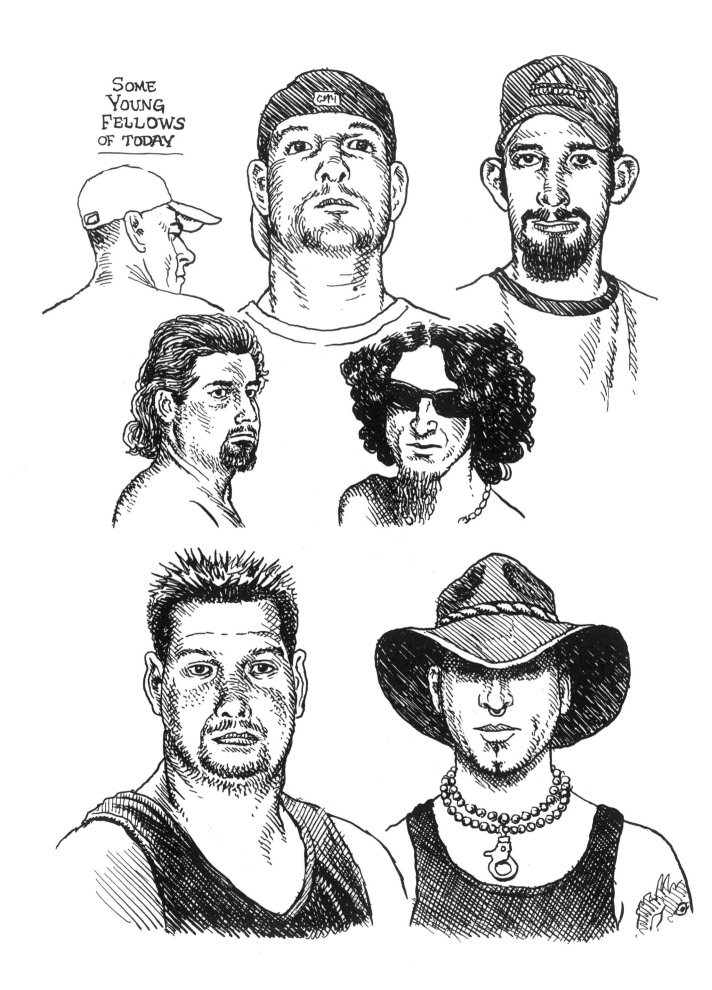

SOME
YOUNG
FELLOWS
OF TODAY

SOME MORE YOUNG
PEOPLE OF TODAY

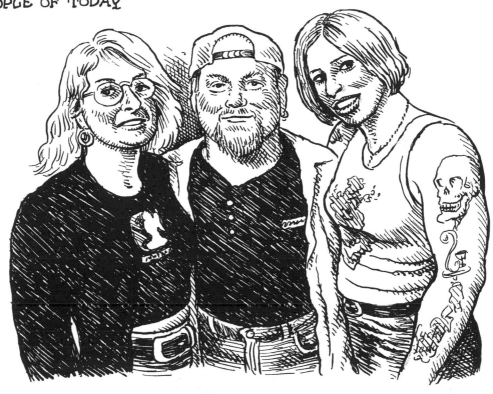

GUY IN BACKWARDS
BALL CAP TRANSFORMED
INTO HENRY VIII

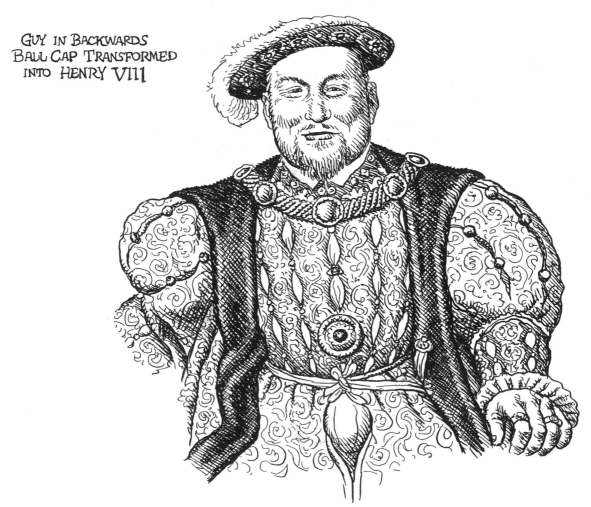

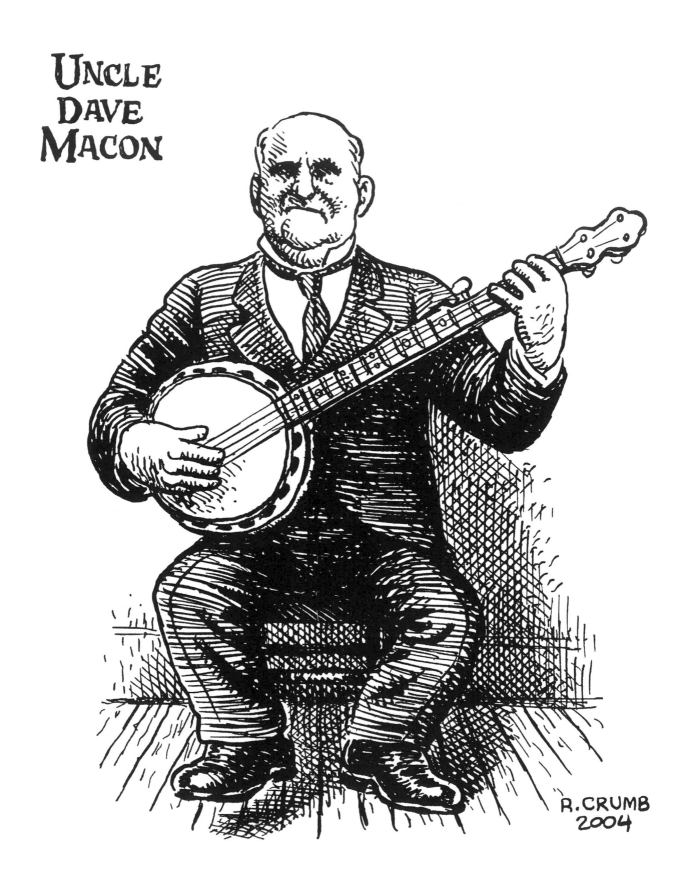

UNCLE
DAVE
MACON

R.CRUMB
2004

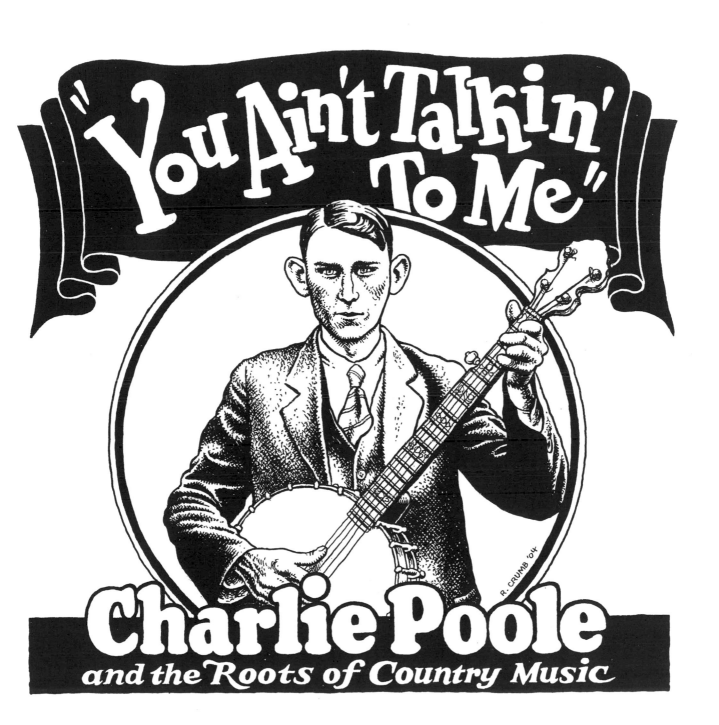

"You Ain't Talkin' To Me"

Charlie Poole
and the Roots of Country Music

R. CRUMB '04

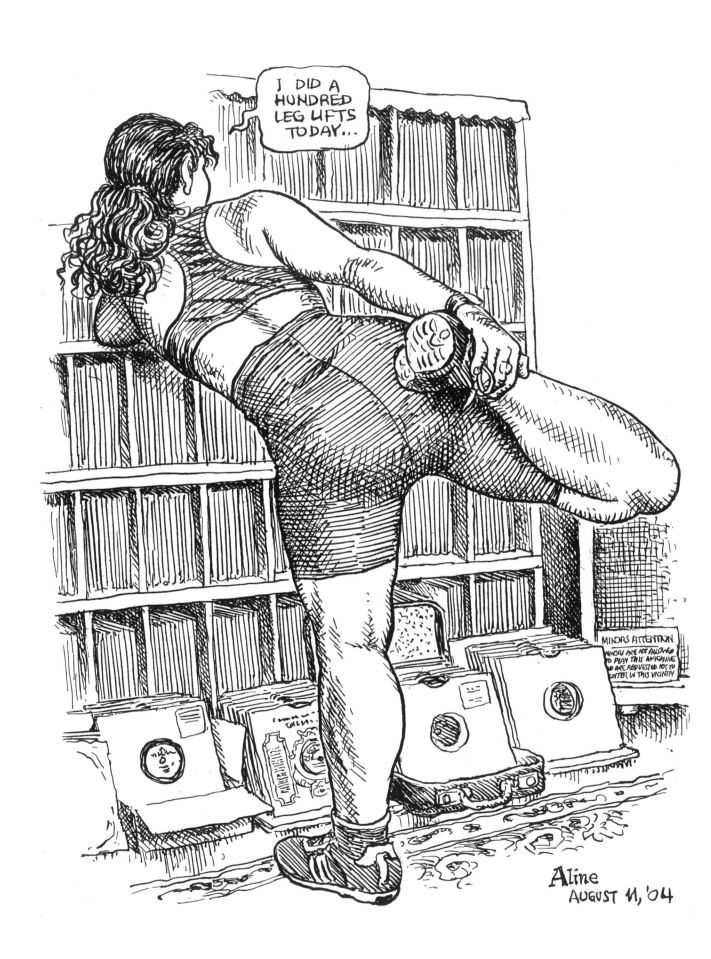

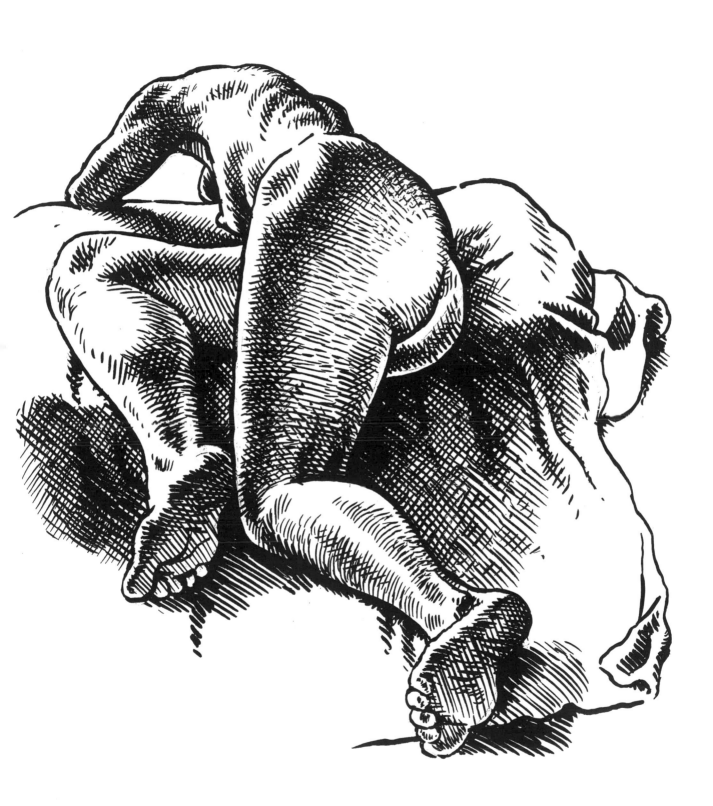

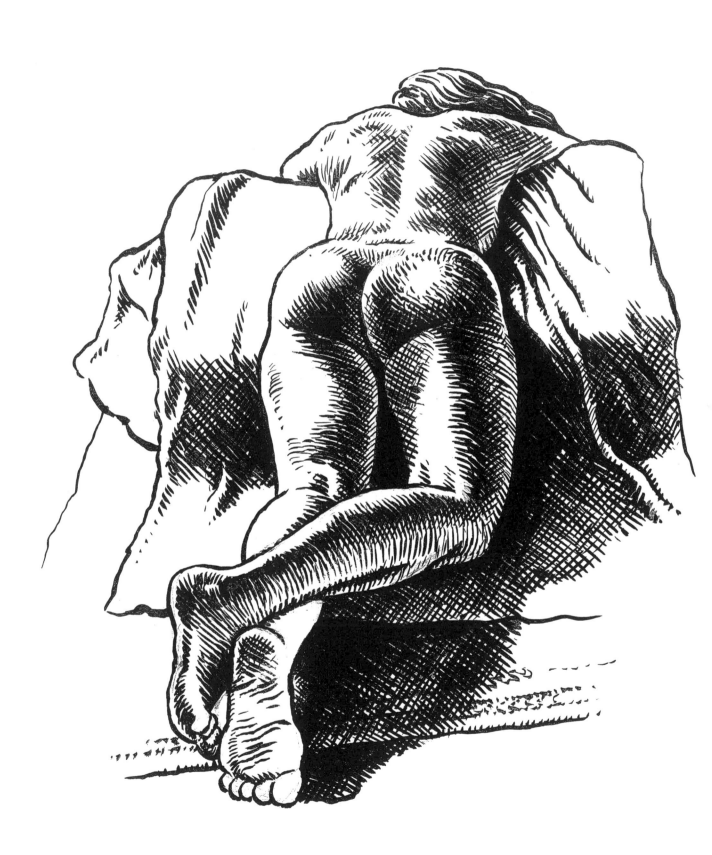

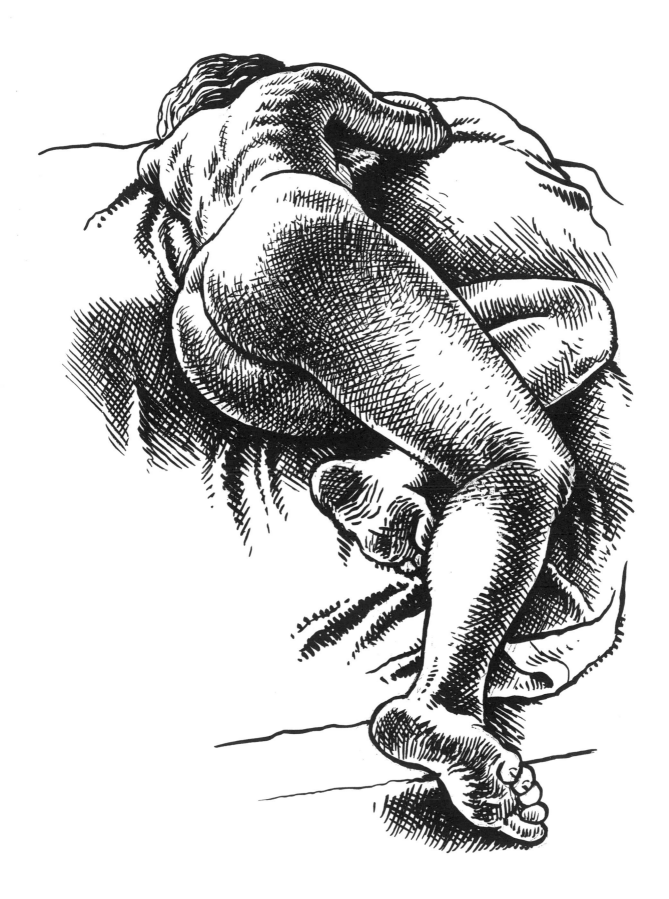

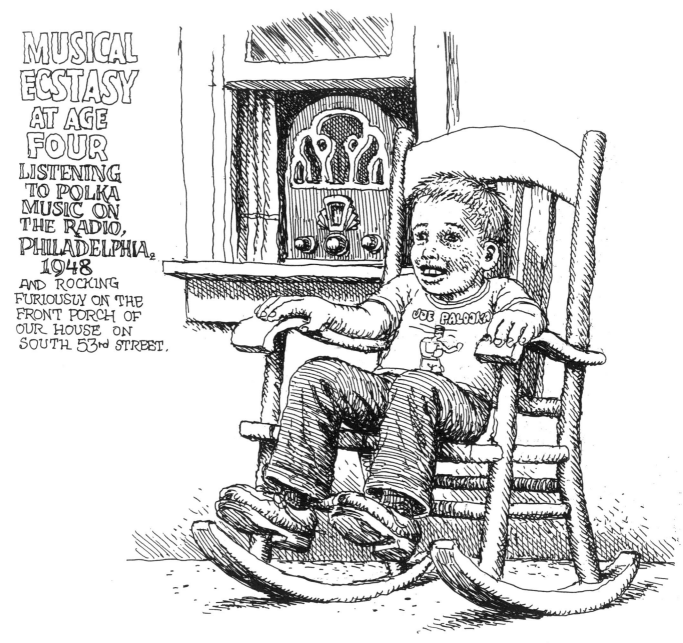

MUSICAL
ECSTASY
AT AGE
FOUR
LISTENING
TO POLKA
MUSIC ON
THE RADIO,
PHILADELPHIA,
1948
AND ROCKING
FURIOUSLY ON THE
FRONT PORCH OF
OUR HOUSE ON
SOUTH 53RD STREET.

R. CRUMB, May '04

RUSS MEYER WITH "VIXENS"

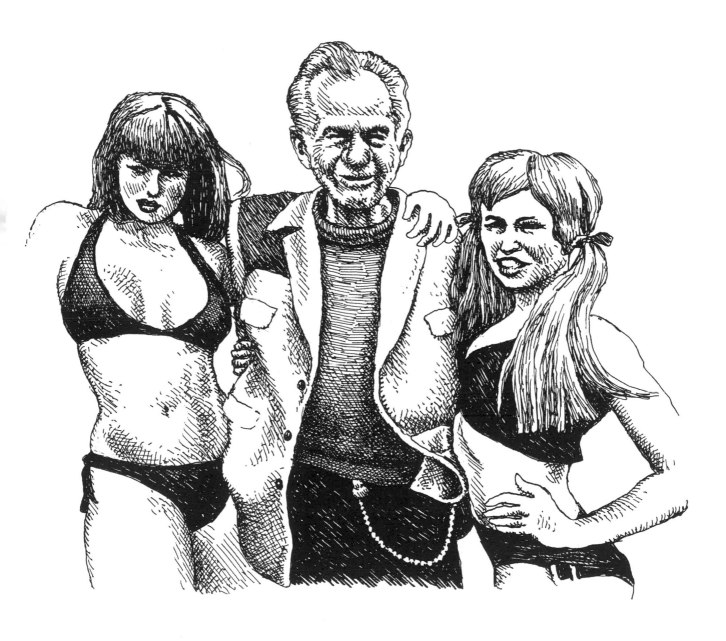

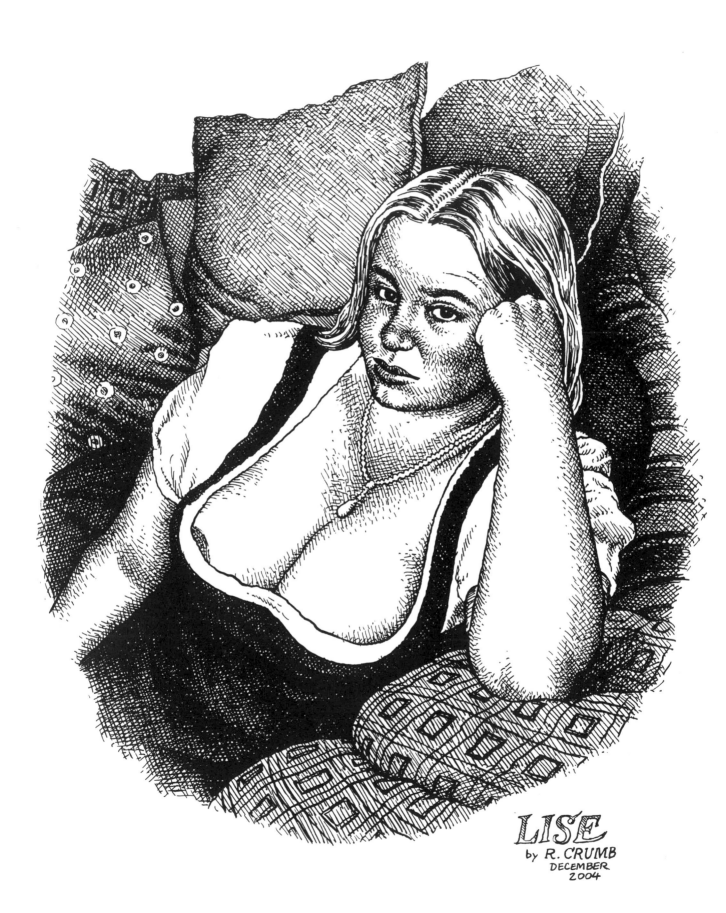

LISE
by R. CRUMB
DECEMBER
2004

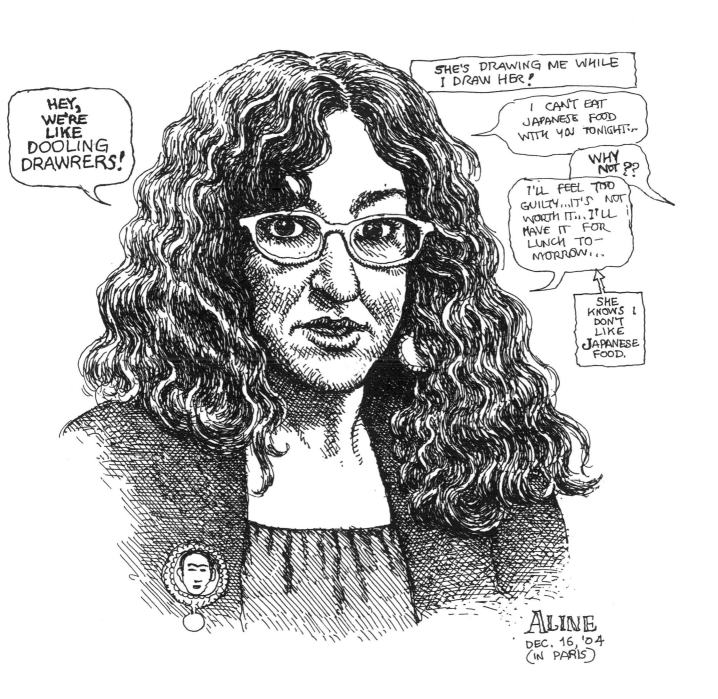

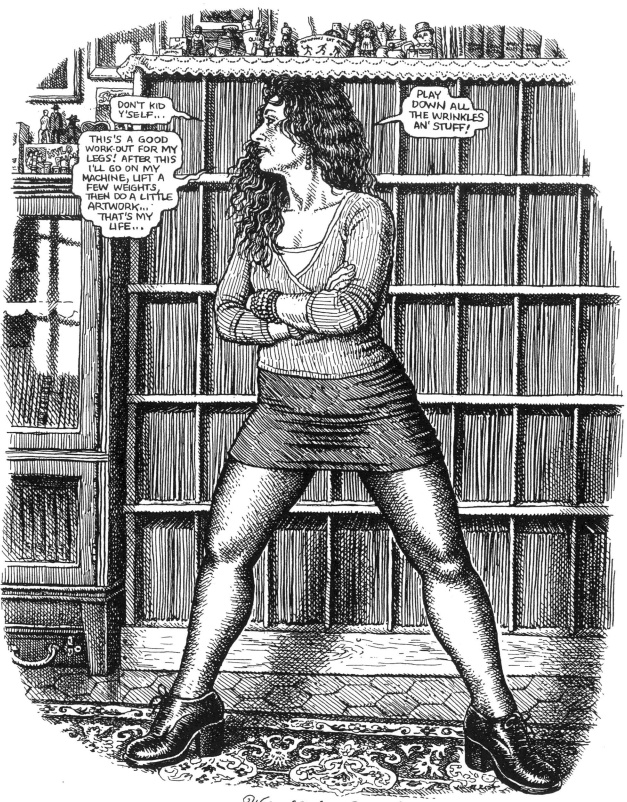

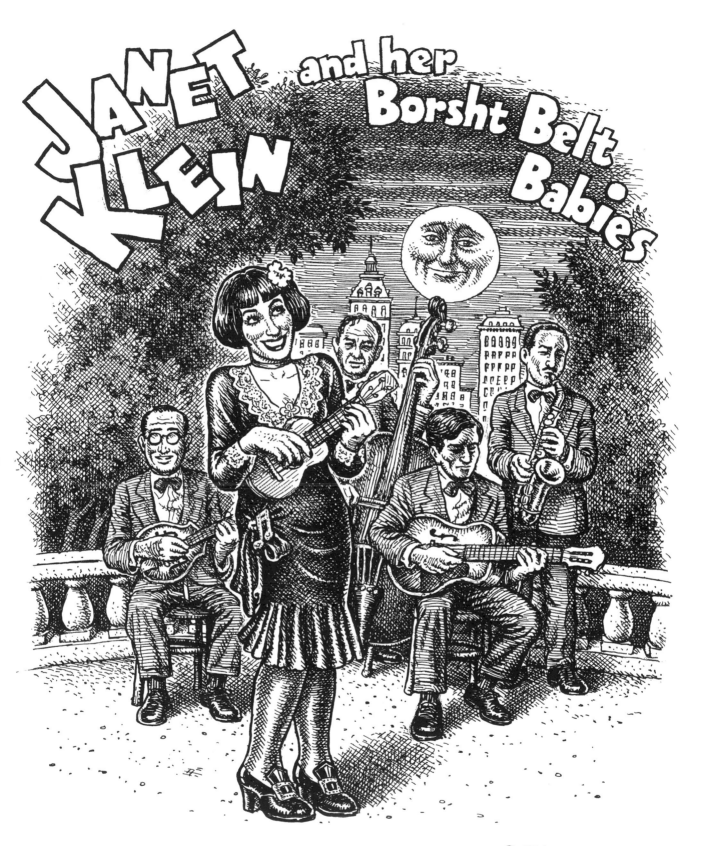

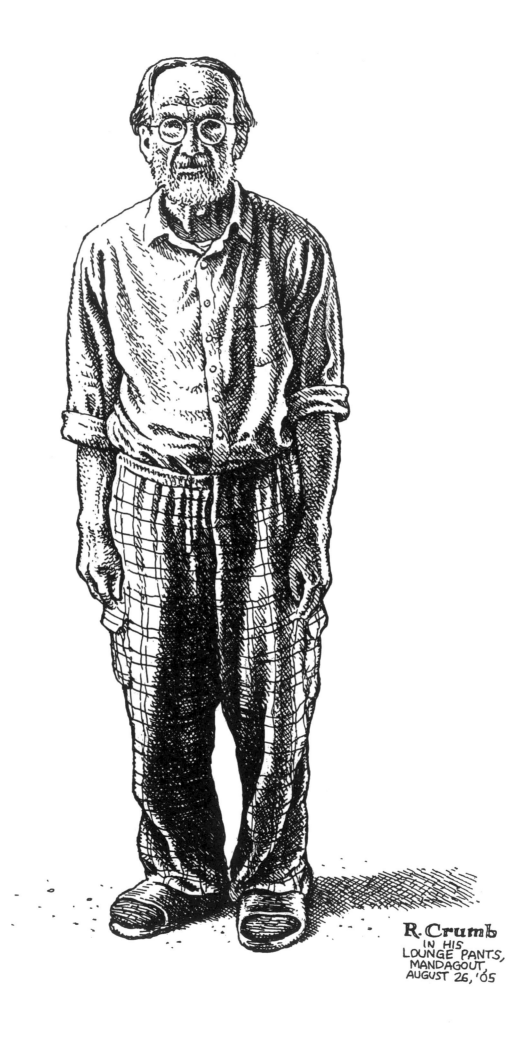

R. Crumb
IN HIS
LOUNGE PANTS,
MANDAGOUT
AUGUST 26, '05

Failure in Sudan

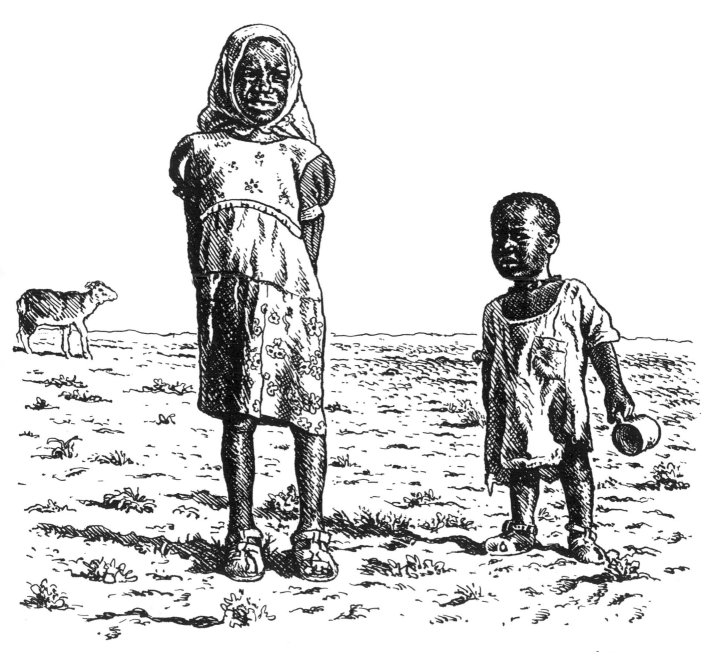

DEC. 6, '05
COVER OF *THE ECONOMIST*
DECEMBER 3RD–9TH, 2005

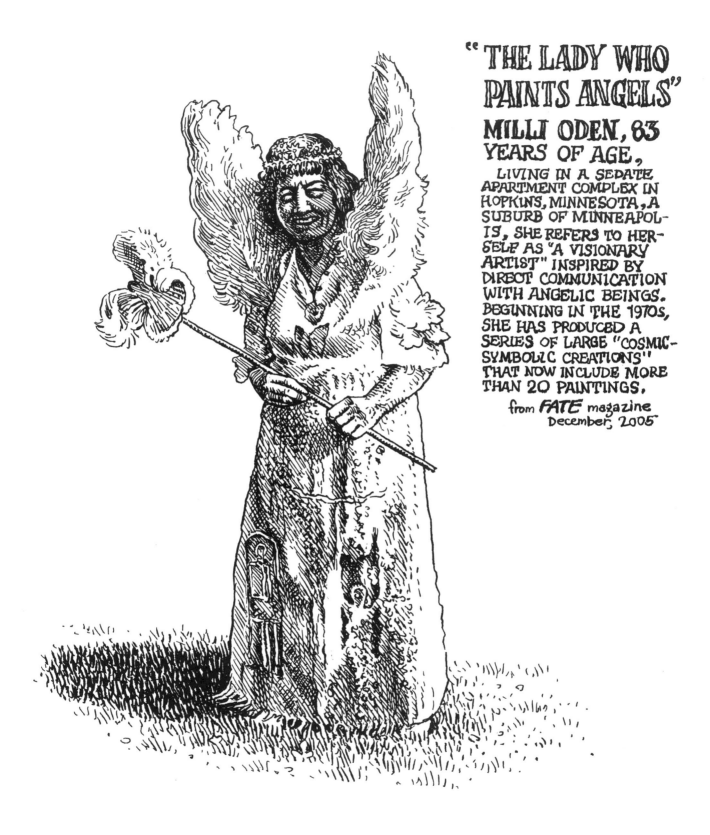

"THE LADY WHO PAINTS ANGELS"

MILLI ODEN, 83 YEARS OF AGE,

LIVING IN A SEDATE APARTMENT COMPLEX IN HOPKINS, MINNESOTA, A SUBURB OF MINNEAPOLIS, SHE REFERS TO HERSELF AS "A VISIONARY ARTIST" INSPIRED BY DIRECT COMMUNICATION WITH ANGELIC BEINGS. BEGINNING IN THE 1970s, SHE HAS PRODUCED A SERIES OF LARGE "COSMIC-SYMBOLIC CREATIONS" THAT NOW INCLUDE MORE THAN 20 PAINTINGS.

from *FATE* magazine December, 2005

March 6, '06